NIKON Z9 USER GUIDE

The Complete Handbook for Understanding the Functionalities and Features of this Digital Camera with Expert Shooting Tips

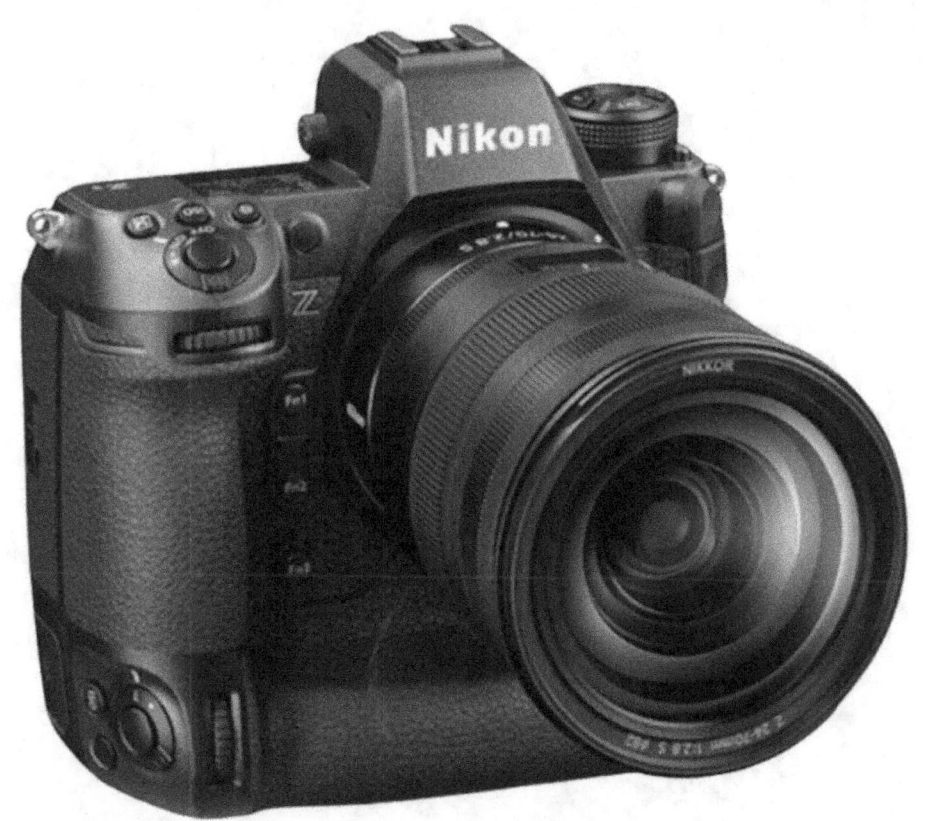

FRANK K. BOOE

Copyright © 2024 Frank K. Booe
All rights reserved.

No part of this publication may be reproduced, distributed, or transmitted in any form or by any means, including photocopying, recording, or other electronic or mechanical methods, without the prior written permission of the publisher, except in the case of brief quotations embodied in critical reviews and certain other non-commercial uses permitted by copyright law

TABLE OF CONTENTS

DISCLAIMER .. 6
CHAPTER ONE ... 8
 INTRODUCTION TO NIKON Z9 ... 8
 Overview of the Nikon Z9 ... 8
 History and Development ... 11
 Target Audience ... 13
CHAPTER TWO ... 16
 CAMERA DESIGN AND BUILD ... 16
 Physical Overview ... 16
 Ergonomics and Handling ... 18
 Weather Sealing and Durability ... 19
 Controls and Button Layout .. 20
CHAPTER THREE ... 22
 TECHNICAL SPECIFICATIONS ... 22
 Sensor and Image Processor ... 22
 Resolution and Image Quality .. 23
 ISO Range and Performance .. 24
 Shutter and Shooting Speed .. 25
 Viewfinder and LCD ... 26
CHAPTER FOUR .. 28
 ADVANCED IMAGING FEATURES .. 28
 Autofocus System .. 28
 Image Stabilization .. 30
 High-Speed Shooting Modes .. 32
 Advanced Metering and Exposure ... 33
 Colour Science and Picture Profiles ... 34
CHAPTER FIVE .. 38
 VIDEO CAPABILITIES ... 38
 Video Recording Resolutions and Frame Rates 38
 Autofocus in Video Mode ... 40

 Audio Recording Options .. 42

 Log Profiles and HDR ... 46

 Slow Motion and Time-Lapse .. 49

CHAPTER SIX ... 52

 CONNECTIVITY AND STORAGE ... 52

 Wireless and Wired Connectivity .. 52

 Dual Card Slots and File Management .. 53

 Remote Control and Tethering ... 55

 Remote Control Options .. 55

 Tethering Options .. 57

 Software for Remote Control and Tethering ... 58

 Firmware Updates .. 59

CHAPTER SEVEN .. 62

 BATTERY AND POWER MANAGEMENT ... 62

 Battery Life and Performance .. 62

 Charging Options ... 63

 Power Accessories and Battery Grips ... 64

 Energy-Saving Tips .. 66

CHAPTER EIGHT ... 68

 LENS COMPATIBILITY AND OPTIONS .. 68

 Nikon Z Mount Lenses .. 68

 Third-Party Lens Support .. 72

 Best Lenses for Different Scenarios .. 73

CHAPTER NINE .. 76

 IMAGES QUALITY AND OUTPUT ... 76

 RAW and JPEG Options .. 76

 Image Processing and Editing .. 77

 Output Formats and Options .. 79

 Printing and Publishing .. 80

CHAPTER TEN .. 82

 USER INTERFACE AND CUSTOMIZATION ... 82

 Menu System Overview ... 82

- Customizing Controls and Buttons ... 84
- My Menu and Quick Access Settings ... 85
- Setting Up User Profiles ... 87

CHAPTER ELEVEN ... 90
MAINTENANCE AND CARE ... 90
- Cleaning and Maintenance ... 90
- Storage and Transportation ... 91
- Troubleshooting Common Issues ... 92

CHAPTER TWELVE ... 94
ACCESSORIES AND ADD-ONS ... 94
- Essential Accessories ... 94
- Lighting and Flash Systems ... 98
- Tripods and Stabilizers ... 100
- Bags and Cases ... 102

CHAPTER THIRTEEN ... 106
BEST PRACTICES AND TIPS ... 106
- Maximizing Image Quality ... 106
- Tips for Efficient Shooting ... 107
- Advanced Techniques ... 109
- Learning from Professionals ... 110

CHAPTER FOURTEEN ... 114
FREQUENTLY ASKED QUESTIONS (FAQ) ... 114
- Common Technical Questions ... 114
- Usage and Performance Questions ... 115
- Troubleshooting Queries ... 117
- Community Support and Forums ... 118

CHAPTER FIFTEEN ... 122
CONCLUSION AND FUTURE OUTLOOK ... 122
- Summary of Key Features ... 122
- Future Trends and Upgrades ... 123
- Continuing Education and Resources ... 124

DISCLAIMER

The contents of this book are provided for informational and entertainment purposes only. The author and publisher make no representations or warranties with respect to the accuracy, applicability, completeness, or suitability of the contents of this book for any purpose.

The information contained within this book is based on the author's personal experiences, research, and opinions, and it is not intended to substitute for professional advice. Readers are encouraged to consult appropriate professionals in the field regarding their individual situations and circumstances.

The author and publisher shall not be liable for any loss, injury, or damage allegedly arising from any information or suggestions contained within this book. Any reliance you place on such information is strictly at your own risk.

Furthermore, the inclusion of any third-party resources, websites, or references does not imply endorsement or responsibility for the content or services provided by these entities.

Readers are encouraged to use their own discretion and judgment in applying any information or recommendations contained within this book to their own lives and situations.

All rights reserved. No part of this book may be reproduced, distributed, or transmitted in any form or by any means, including photocopying, recording, or other electronic or mechanical methods, without the prior written permission of the publisher, except in the case of brief quotations embodied in critical reviews and certain other non-commercial uses permitted by copyright law.

Thank you for reading and understanding this disclaimer.

CHAPTER ONE
INTRODUCTION TO NIKON Z9

Overview of the Nikon Z9

The Nikon Z9 is a flagship mirrorless camera, released in 2021, and represents a significant leap in technology for Nikon. It is designed to meet the rigorous demands of professional photographers and videographers, offering high-end performance, durability, and versatility. Below is a detailed overview of the Nikon Z9's features and specifications:

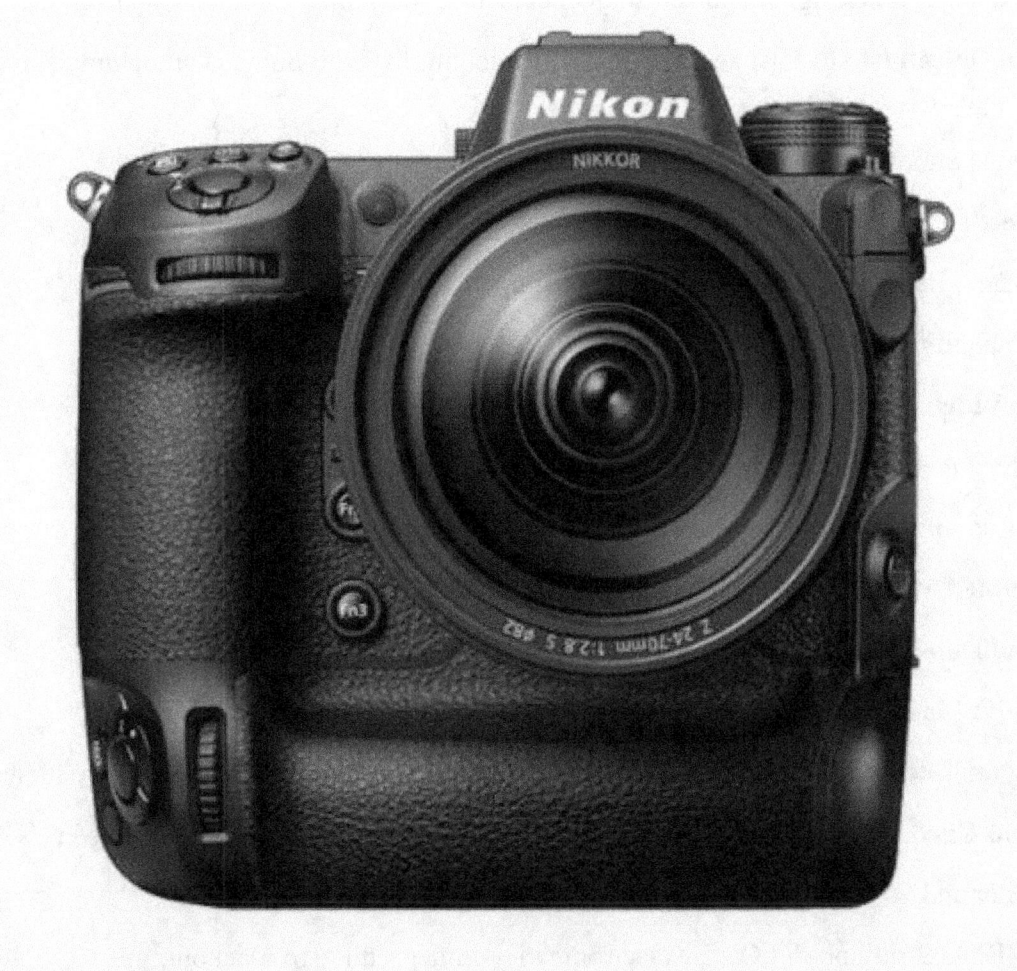

Key Features and Specifications

1. Image Sensor and Processor

- **Sensor:** 45.7-megapixel stacked CMOS sensor.

- **Processor:** EXPEED 7, Nikon's most powerful image processing engine.

- **No Mechanical Shutter:** Uses a completely electronic shutter, eliminating shutter wear and enabling ultra-high-speed continuous shooting and silent operation.

2. Image Quality
- **ISO Range:** 64 to 25,600 (expandable to 32-102,400).
- **Dynamic Range:** Wide dynamic range suitable for a variety of lighting conditions.
- **10-bit HEIF Support:** Offers more detail and dynamic range than traditional JPEG.

3. Autofocus System
- **AF Points:** 493 on-sensor phase-detection AF points.
- **Real-time Tracking:** Advanced subject detection for humans, animals, and vehicles.
- **Eye Detection AF:** Fast and accurate eye-tracking for both humans and animals, including birds in flight.

4. Continuous Shooting
- **Speed:** Up to 120 frames per second (fps) at 11-megapixel resolution, and 20 fps at full resolution.
- **Buffer:** Large buffer capable of capturing up to 1,000 RAW images in a burst.

5. Video Capabilities
- **8K Video:** Shoots 8K UHD video at up to 30p, 4K UHD at up to 120p.
- **Internal Recording:** 12-bit RAW and ProRes 422 HQ recording internally.
- **N-Log and HLG Support:** For professional colour grading.
- **Frame Grabs:** Extract 33-megapixel stills from 8K video or 11-megapixel stills from 4K video.

6. Build and Durability
- **Body:** Magnesium alloy construction for robustness and weather sealing.
- **Ergonomics:** Improved grip and button layout for better handling, especially with longer lenses.
- **Dual Card Slots:** Supports CFexpress Type B cards for high-speed data transfer.

7. Viewfinder and Display
- **EVF:** 3.69-million-dot OLED electronic viewfinder with zero blackout.
- **LCD:** 3.2-inch, 2.1-million-dot touchscreen that tilts in four directions.
- **Dual Coating:** Reduces reflections and smudges.

8. Connectivity and Workflow
- **Wi-Fi and Bluetooth:** For wireless image transfer and remote control.
- **Ethernet Port:** For fast, stable wired connections.
- **USB-C:** For charging and data transfer.

9. Battery Life

- **Battery:** EN-EL18d battery, compatible with previous EN-EL18 variants.
- **Battery Life:** Approximately 740 shots per charge (CIPA standard).

10. Additional Features

- **Focus Stacking:** For macro photography and increased depth of field.
- **Multiple Exposure Modes:** Creative in-camera effects.
- **GPS:** Built-in for geotagging images.

Use Cases and Applications

Professional Photography

- **Sports and Wildlife:** High-speed continuous shooting and advanced AF tracking are ideal for capturing fast-moving subjects.
- **Portraits and Events:** Exceptional eye detection and dynamic range make it perfect for portraiture and wedding photography.
- **Landscape and Studio:** High resolution and dynamic range offer detailed and vibrant landscape images.

Videography

- **Cinematic Production:** 8K and 4K capabilities with advanced recording options support high-quality video production.
- **Documentary and Broadcast:** The robust body, extensive battery life, and connectivity options suit on-the-go shooting and live broadcasting.

Competitive Edge

The Nikon Z9 stands out due to its:

- **Innovative Sensor and Shutter:** The first Nikon camera to forgo a mechanical shutter entirely, reducing maintenance and enhancing shooting speed.
- **Advanced AF System:** Sophisticated autofocus with AI-driven subject detection offers a competitive edge in capturing dynamic scenes.
- **Versatile Video Capabilities:** Professional-grade video features cater to both high-end film production and practical, everyday video needs.

In summary, the Nikon Z9 is a powerhouse mirrorless camera that combines cutting-edge technology with robust performance. It is designed for professionals who require speed, reliability, and exceptional image quality across a wide range of photographic and video applications. Whether in the studio, on a sports field, or in the wild, the Z9 is built to deliver outstanding results.

History and Development

The Nikon Z9's development is part of a broader trend in the camera industry towards advanced mirrorless technology, driven by the need to cater to professional photographers and videographers in a competitive market. The history and development of the Nikon Z9 reflect a significant evolution in Nikon's approach to high-end camera design and technology.

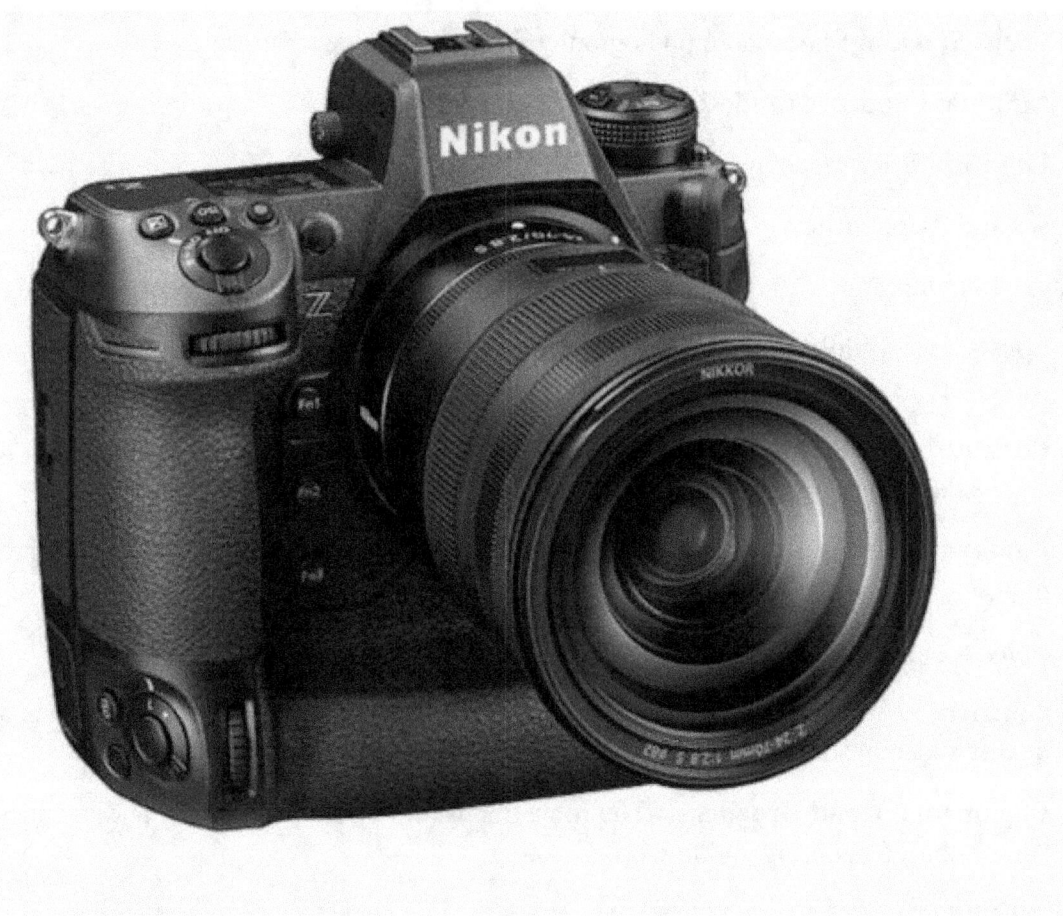

Nikon's Mirrorless Journey

- **Early Beginnings:** Nikon entered the mirrorless market in 2011 with the Nikon 1 series, which featured a small sensor and was not aimed at professional users.

- **Z Series Introduction:** In 2018, Nikon launched the Z6 and Z7, marking a serious entry into the full-frame mirrorless segment. These models introduced the Z-mount, a new lens mount with a wider diameter and shorter flange distance, allowing for improved lens designs.

Development of the Nikon Z9

Conceptualization and Planning

- **Market Demand:** The Z9 was conceived in response to the growing demand for mirrorless cameras with capabilities rivalling or exceeding those of professional DSLRs, such as the Nikon D5 and D6.

- **Professional Input:** Nikon engaged with professional photographers and videographers to understand their needs, leading to a camera designed to excel in sports, wildlife, and high-end video production.

Technological Innovations

- **Sensor Development:** The Z9 features a new 45.7-megapixel stacked CMOS sensor, a significant step up from previous models. The stacked design allows for faster readout speeds and improved performance in various lighting conditions.
- **Processor Advancements:** Nikon introduced the EXPEED 7 processor, which provides the necessary computational power to handle the high-speed shooting, advanced autofocus, and video capabilities of the Z9.
- **Electronic Shutter:** One of the most revolutionary features is the complete reliance on an electronic shutter, eliminating the need for a mechanical shutter. This allows for silent operation and reduces wear and tear, a critical feature for professional use.

Development Timeline

Early Development Stages (2018-2020)

- **R&D Focus:** Following the launch of the Z6 and Z7, Nikon began focusing on developing a flagship mirrorless camera. The goal was to create a model that could not only match but exceed the performance of their high-end DSLRs.
- **Prototype Testing:** Early prototypes of the Z9 underwent extensive testing, particularly in challenging conditions such as sports events and wildlife photography, to ensure reliability and performance.

Technological Challenges and Solutions

- **Heat Management:** One of the critical challenges was managing heat generated by the high-speed sensor and processor, especially during continuous shooting and video recording. Nikon developed advanced cooling mechanisms to mitigate this issue.
- **Autofocus Precision:** Nikon enhanced its autofocus algorithms, incorporating deep learning to improve subject recognition and tracking accuracy for a variety of subjects, including humans, animals, and vehicles.

Announcement and Release (2021)

- **Official Launch:** The Nikon Z9 was officially announced on October 28, 2021. It quickly garnered attention for its groundbreaking features and performance.
- **Market Reception:** The Z9 was well-received, praised for its speed, image quality, and comprehensive feature set, positioning it as a strong competitor in the professional mirrorless market.

Impact and Legacy

Industry Influence

- **Benchmark for Performance:** The Z9 set new standards for speed and functionality in mirrorless cameras, influencing competitors to push the boundaries of their own high-end offerings.
- **Adoption by Professionals:** Many professional photographers and videographers who were loyal to DSLRs transitioned to the Z9, appreciating its robust build and advanced capabilities.

Future Development

- **Continued Innovation:** The success of the Z9 has driven Nikon to continue investing in advanced mirrorless technology, leading to the development of subsequent models that build on the Z9's innovations.
- **Mirrorless Dominance:** The Z9 signifies Nikon's commitment to a mirrorless future, shaping the direction of their camera technology development for years to come.

Technological Advancements and Innovations

Key Innovations in the Z9

- **Stacked Sensor:** Provides faster data readout and better performance in high-speed shooting and video.
- **Electronic Shutter:** Allows for a silent, vibration-free shooting experience with a high burst rate and eliminates rolling shutter artifacts in most situations.
- **Advanced Autofocus:** Leveraging deep learning for precise subject recognition and tracking.
- **8K Video:** Among the first in its class to offer internal 8K video recording, catering to high-end video production needs.

The Nikon Z9's history and development highlight a significant shift in Nikon's approach to camera technology, reflecting a deep understanding of the needs of professional users. It represents a culmination of years of technological advancements and a commitment to providing top-tier performance in the increasingly competitive world of mirrorless cameras. The Z9 not only sets a high bar for Nikon's future products but also pushes the entire industry towards more innovative and capable mirrorless systems.

Target Audience

The Nikon Z9 is definitely aimed at professional photographers and videographers. Here's a breakdown of who would benefit most:

- **Working professionals:** Wedding photographers, sports and wildlife photographers, photojournalists, and videographers who need top-of-the-line performance and features.
- **High-end enthusiasts:** Serious hobbyists who shoot a lot and require the best possible image and video quality, even if it means a bigger investment.

- **Specific niches:** Event photographers who need fast autofocus and low-light performance, or nature photographers who require fast burst rates for capturing fleeting moments of wildlife.

Here's who might want to consider a different camera:

- **Casual photographers:** If you're a casual shooter who doesn't need the fastest speeds or most advanced features, a less expensive mirrorless camera might be a better fit.
- **Budget-conscious buyers:** The Z9 is a pricey piece of equipment. If you're on a tight budget, there are plenty of excellent mirrorless cameras available at lower price points.
- **Videographers who prioritize portability:** The Z9 is a bit on the larger and heavier side. If portability is a major concern, you might look for a more compact mirrorless camera for video work.

CHAPTER TWO
CAMERA DESIGN AND BUILD

Physical Overview

1. Build and Design

Materials and Construction

- **Body Material:** The Z9 features a magnesium alloy construction, providing a balance between strength and weight. This material ensures durability and helps in dissipating heat generated by the internal components.

- **Weather Sealing:** The camera is extensively weather-sealed against dust and moisture, making it suitable for challenging environments like rain, snow, and dusty conditions. This is crucial for outdoor photography and adventure shoots.

Dimensions and Weight

- **Dimensions:** 149 mm (width) x 149.5 mm (height) x 90.5 mm (depth). The camera is relatively compact for a flagship model but retains a substantial presence.

- **Weight:** Approximately 1340 grams (including battery and memory card). This weight reflects the camera's robust construction and advanced technology, striking a balance between portability and durability.

2. Controls and Interfaces

Top Controls

- **Mode Dial:** The top panel includes a mode dial for quick access to shooting modes such as P, S, A, M, and custom modes. The dial is lockable to prevent accidental changes.

- **Control Panel:** There is a monochrome LCD panel on the top for quick viewing of key settings like ISO, shutter speed, and battery level.

Rear Controls

- **Joystick:** A multi-directional joystick is provided for precise AF point selection and menu navigation. This is particularly useful for photographers who need to quickly adjust focus points.

- **AF-ON Button:** Positioned for easy thumb access, allowing for back-button focusing, a feature favoured by many professional photographers for precise focus control.

Front and Side Controls

- **Function Buttons:** Customizable function buttons (Fn1 and Fn2) on the front provide quick access to frequently used settings.

- **Ports:** The left side of the camera houses various ports including a full-size HDMI, USB-C, microphone input, headphone output, and a LAN port for wired network connections.

3. Displays and Viewfinder

Electronic Viewfinder (EVF)

- **Specifications:** The Z9 features a 3.69-million-dot OLED EVF with a refresh rate of up to 120 fps, providing a clear and responsive view.
- **Blackout-Free Shooting:** The EVF offers a real-time, blackout-free view even during continuous shooting, which is crucial for tracking fast-moving subjects.

Rear LCD Screen

- **Type:** A 3.2-inch tilting LCD touchscreen with 2.1 million dots.
- **Articulation:** The screen can tilt in four directions, making it versatile for high-angle, low-angle, and vertical shooting. The articulation is particularly useful for videographers and photographers who need to shoot from unconventional angles.

4. Storage and Battery

Dual Card Slots

- **Card Type:** The Z9 features dual CFexpress Type B card slots, which support high-speed data transfer essential for handling large RAW files and 8K video recording.
- **Card Slot Design:** The slots are designed to provide redundancy, allowing simultaneous recording to both cards for backup or overflow purposes.

Battery

- **Battery Model:** EN-EL18d, a high-capacity battery that is also backward compatible with previous EN-EL18 variants.
- **Battery Life:** The camera offers approximately 740 shots per charge based on CIPA standards, with extended life in real-world use.

5. Additional Features

Connectivity

- **Wireless:** Built-in Wi-Fi and Bluetooth for wireless image transfer and remote control using Nikon's SnapBridge app.
- **Wired:** The inclusion of a LAN port allows for high-speed wired network connections, catering to studio work and event photography where immediate image transfer is critical.

Cooling System

- **Heat Management:** The Z9 incorporates an advanced cooling system to manage heat generated during prolonged shooting and 8K video recording sessions, preventing overheating and ensuring consistent performance.

6. Customizability and Expandability

Lens Mount

- **Z-Mount:** The camera uses Nikon's Z-mount, which is known for its large diameter and short flange distance. This mount supports a wide range of NIKKOR Z lenses and allows for the use of F-mount lenses via an adapter.

Accessory Compatibility

- **Battery Grip:** The integrated vertical grip supports additional batteries for extended shooting time and provides extra controls for vertical shooting.
- **External Accessories:** The camera supports various accessories including external flashes, microphones, and monitors, expanding its usability in different shooting scenarios.

The Nikon Z9 is a well-crafted, robust, and versatile mirrorless camera designed to meet the demands of professional photographers and videographers. Its thoughtful ergonomics, advanced electronic viewfinder, versatile LCD, and comprehensive control layout make it an excellent tool for a wide range of applications, from sports and wildlife photography to studio work and high-end video production.

Ergonomics and Handling

The Nikon Z9's ergonomics and handling are a bit of a mixed bag, with some definite strengths and a couple of weaknesses to consider:

Strengths:

- **Built for comfort:** The Z9 boasts a full-size body with a built-in vertical grip, which makes it comfortable to hold and use for extended periods, especially for photographers with larger hands.
- **Solid build:** It's constructed from a magnesium alloy and weather-sealed, making it feel very robust and ready for tough shooting conditions.
- **Button layout:** Most buttons are well-placed and easy to reach, with a good balance for one-handed operation. The joystick and AF-ON button are conveniently positioned for quick focus adjustments.
- **Customizability:** The Z9 offers extensive customization options, allowing photographers to personalize button functions for their specific shooting style. This includes five dedicated function buttons that can be programmed for frequently used settings.

Weaknesses:

- **Size and weight:** The built-in grip and overall larger body make the Z9 a heavier camera compared to some mirrorless options. This can be tiring to carry around all day, especially for photographers who value portability.

- **Memory card door:** The memory card compartment has a locking door that some users find a little awkward to open, particularly when wearing gloves.

The Nikon Z9's ergonomics are geared towards professional photographers who prioritize comfort and secure handling during long shoots. It might feel bulky to some users, but the well-designed grip and button layout can make up for it. If you have the opportunity, try holding a Z9 at a camera store to see if the size and weight feel manageable for you.

Weather Sealing and Durability

The Nikon Z9 is built to withstand the elements, making it a great choice for professional photographers who shoot in challenging environments. Here's a breakdown of its weather sealing and durability:

Weather Sealing:

- **Extensive sealing:** The Z9 boasts extensive weather sealing throughout its body. This means it's protected against dust, moisture, and splashes.

- **Magnesium alloy body:** The camera body is constructed from a magnesium alloy, which is known for being lightweight yet strong and durable.

- **Confidence in harsh conditions:** With proper care, you can feel confident using the Z9 in light rain, snow, or dusty environments.

Durability:

- **Built to last:** The overall build quality of the Z9 exudes a sense of robustness. Professional photographers expect their gear to take a beating, and the Z9 seems up to the task.

- **Solid feel:** Just holding the camera, you'll get a sense of its solid construction. This inspires confidence when shooting in less-than-ideal conditions.

Things to Consider:

- **Weather sealing limitations:** While weather-sealed, it's not submersible. Avoid dunking it in water or exposing it to heavy downpours for extended periods.

- **Weather sealing and lenses:** Remember, weather sealing effectiveness depends on the lenses you use. Make sure your Z mount lenses are also weather-sealed for complete protection.

The Nikon Z9's weather sealing and durability are top-notch. It's a camera built to take on demanding professional use, and you can expect it to perform well in challenging environments. Just remember, no camera is completely weatherproof, so common sense is still important when shooting in harsh conditions.

Controls and Button Layout

The Nikon Z9 offers a comprehensive set of controls and buttons to give you precise control over your photography and videography. Here's a breakdown of the key controls and their functions, along with an image of the Z9 to help you visualize their placement:

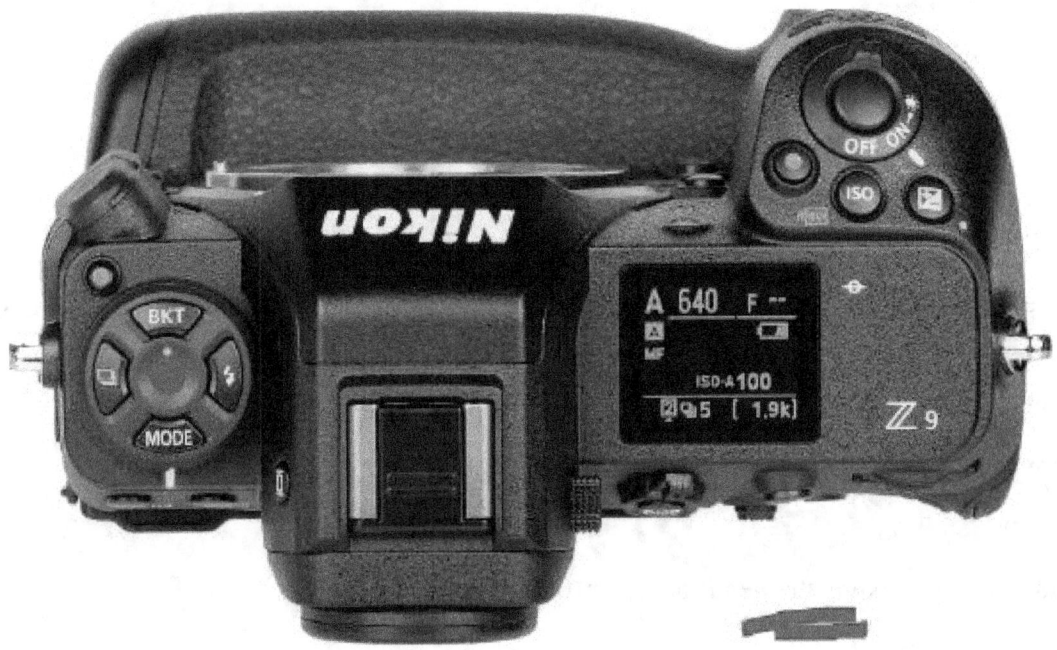

Top Dial:

- Controls shooting modes like Program (P), Aperture Priority (A), Shutter Priority (S), and Manual (M).

Front Dial:

- Typically used for adjusting aperture in Aperture Priority mode or shutter speed in Shutter Priority mode.

Rear Dial:

- Used in conjunction with the main command dial for exposure compensation or white balance adjustments.

Exposure Compensation Button (+/-):

- Allows you to quickly adjust exposure above or below the camera's metered settings.

ISO Button:

- Provides quick access to changing ISO settings, which control light sensitivity.

White Balance Button (U):

- For setting the white balance, which ensures colours appear accurate under different lighting conditions.

Movie Record Button:

- Starts and stops movie recording.

Playback Button:

- Switches the camera to playback mode to review captured photos and videos.

AF-On Button:

- A dedicated button for locking focus independently of the shutter release button. Useful for situations where you want to recompose your shot after focusing.

Multi-selector:

- A joystick for navigating menus and selecting focus points.

Thumbstick:

- Another way to navigate menus and control settings.

Function (Fn) Buttons:

- Four programmable buttons that can be customized to access frequently used settings.

MENU Button:

- Opens the main menu for accessing all camera settings.

i Button:

- Brings up the context-sensitive quick menu that provides easy access to frequently adjusted settings depending on the shooting mode.

DISP Button:

- Cycles through different information displays on the camera's screen or viewfinder.

Rear LCD Screen:

- A large touchscreen LCD that can be used for composing shots, reviewing images and videos, and navigating menus.

Overall, the Nikon Z9's controls and button layout are well-designed and customizable, offering photographers and videographers a high degree of control over their work. By spending some time familiarizing yourself with the button placements and how to customize the Fn buttons, you can optimize the Z9 for your specific shooting style.

CHAPTER THREE
TECHNICAL SPECIFICATIONS

Sensor and Image Processor

The core of the Nikon Z9's power lies in its sensor and image processor. Here's a detailed look at both, along with images for reference:

Sensor:

- **Type:** Stacked CMOS sensor

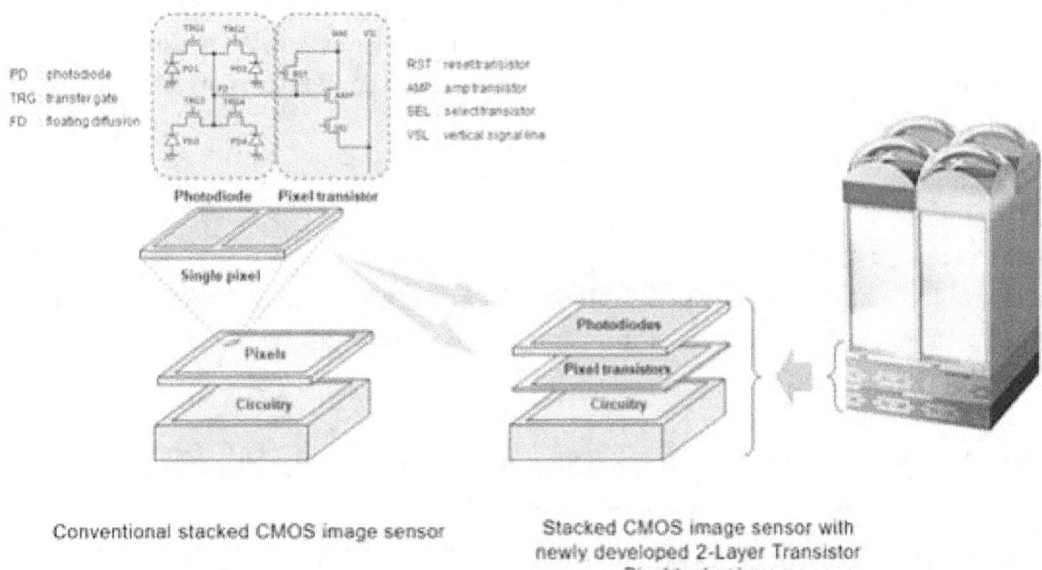

- **Megapixels:** 45.7MP

- **Full-frame (FX format):** Delivers excellent low-light performance and the ability to capture high-resolution images with a shallow depth of field.

- **BSI (Back-illuminated) design:** Improves low-light performance by allowing more light to reach the photodiodes.

- **Fast readout speeds:** Enables fast continuous shooting and minimizes rolling shutter distortion during fast panning or capturing moving subjects.

- **Dual gain sensor:** Allows for cleaner images at higher ISOs by using separate amplification processes for lower and higher ISO ranges.

- **ISO range:** 64-25600 (expandable to 32-102400) - Offers a wide range of sensitivity for shooting in various lighting conditions.

Image Processor:

- **Name:** EXPEED 7

- **Processing power:** Enables features like fast continuous shooting, blackout-free viewfinder, high-resolution video recording, and improved image quality with noise reduction.

- **Dual data pipelines:** Contribute to the camera's speedy performance and allow for features like the 120 fps burst mode and real-time autofocus.

- **Buffer:** Large buffer allows for extended bursts of RAW images at high frame rates.

The combination of the 45.7MP stacked BSI sensor and the EXPEED 7 processor makes the Nikon Z9 a powerful tool for professional photographers. It delivers high-resolution images with excellent low-light performance, fast continuous shooting speeds, and minimal shutter distortion. While some competitors might offer slightly better low-light performance, the Z9 remains a top contender in overall image quality and processing power.

Resolution and Image Quality

The Nikon Z9 boasts a 45.7-megapixel stacked CMOS sensor, capturing high-resolution images with impressive detail. Here's a breakdown of its resolution and image quality:

Resolution:

- **45.7 megapixels:** This translates to high-resolution images with plenty of detail, allowing you to crop significantly or create large prints without sacrificing quality.

- **Flexibility for various outputs:** Suitable for professional photographers who need to deliver high-quality images for print, web, or stock photography.

Image Quality:

- **Excellent detail:** The high megapixel count and high-quality sensor capture sharp images with fine details.

- **Good low-light performance:** The BSI sensor design and the EXPEED 7 processor work together to deliver clean images even in low-light conditions. However, some competitors might perform slightly better in extremely low-light situations.

- **Dynamic range:** The sensor captures a wide range of tones from highlights to shadows, allowing for more flexibility in post-processing.

- **High ISO performance:** While low-light performance is good, images may show some noise at higher ISOs. The dual gain sensor helps mitigate noise at moderate ISOs, but noise becomes more noticeable at very high ISOs.

Here are some additional factors that affect image quality:

- **Lens choice:** A high-quality lens will significantly contribute to sharp and detailed images.
- **Shooting conditions:** Proper lighting, camera settings, and technique will also play a role in achieving optimal image quality.

The Nikon Z9 delivers excellent image quality with high resolution, good low-light performance, and wide dynamic range. While some competitors might inch ahead in specific areas like low-light performance, the Z9 remains a powerful tool for professional photographers who require exceptional image quality for various applications. If you prioritize absolute low-light dominance, researching competitor options might be worthwhile. However, for most professional photography needs, the Z9's image quality stands out.

ISO Range and Performance

The Nikon Z9 boasts a wide ISO range and good overall performance, but it's important to understand its strengths and limitations. Here's a breakdown:

ISO Range:

- **Native range:** 64 - 25600
- **Expandable range:** 32 - 102400

Image at ISO Range:

- **Low ISO (64-400):** Images are clean with minimal noise, perfect for situations with good lighting.
- **Medium ISO (800-6400):** Noise becomes slightly more noticeable, but images remain usable for most applications, especially with moderate post-processing. This is a good sweet spot for balancing image quality and low-light shooting.
- **High ISO (12800-25600):** Noise becomes more prominent, but details are still recoverable with good noise reduction software. These ISOs are suitable for low-light situations where capturing the moment is more critical than pristine image quality.
- **Extended ISO (51200-102400):** Only recommended for emergencies or extreme low-light scenarios where capturing any detail is crucial. Expect significant noise at these ranges.

The Nikon Z9's ISO performance is good, but not necessarily the best on the market. It delivers clean images at lower ISOs and maintains good detail up to ISO 6400. For professional work where absolute low-light dominance is required, some competitor cameras might offer a slight edge. However, the Z9 remains versatile with its extended ISO range, allowing you to capture images even in very challenging lighting conditions.

Here are some additional factors to consider:

- **Noise reduction software:** Can significantly improve image quality at higher ISOs, especially with RAW files.

- **Shooting style:** If you primarily shoot in well-lit environments, ISO performance might not be a major concern. However, if low-light photography is a frequent requirement, then the Z9's capabilities or competitor options with even better low-light performance would need to be weighed.

The Nikon Z9 offers a wide ISO range with good overall performance, making it suitable for most professional photography applications. If absolute low-light dominance is your top priority, explore competitor options. Otherwise, the Z9's image quality and versatility are strong selling points.

Shutter and Shooting Speed

The Nikon Z9 boasts impressive shutter speeds and shooting capabilities, making it ideal for capturing fast action and fleeting moments. Here's a breakdown of its shutter system and shooting speeds with images for reference:

Shutter System:

- **Mechanical focal-plane shutter:** This offers a reliable and familiar shooting experience for photographers accustomed to DSLRs.

- **Electronic shutter:** Provides several advantages including:
 - **Silent shooting:** Great for situations where silence is crucial, such as wildlife photography or events where noise would be disruptive.
 - **Faster shutter speeds:** Enables capturing extremely fast-moving subjects or using wider apertures for creative effects in bright light.

Shutter Speeds:

- **Mechanical shutter:** Speeds range from 30 seconds to 1/8000 of a second.

- **Electronic shutter:** Offers a wider range of speeds from 15 minutes to a mind-blowing 1/32000 of a second! This allows you to freeze even the fastest action with incredible detail.

Fast Continuous Shooting:

- The Z9 can capture images at an impressive 20 frames per second with full autofocus and autoexposure, making it ideal for sports photography, wildlife action, or capturing fast-paced events.

Flash Sync Speed:

- **Flash sync speed:** 1/200th of a second. This is a bit slower than some competitor cameras, which might be a limitation for some flash photography applications.

Here are some additional factors to consider:

- **Electronic shutter limitations:** While offering advantages, electronic shutters can sometimes cause banding issues with artificial lighting. The Z9 has features to mitigate this, but it's something to be aware of.

- **Rolling shutter distortion:** At very fast electronic shutter speeds, there can be a slight distortion of moving subjects, but this is generally minimal with the Z9's sensor.

The Nikon Z9's shutter system and shooting speeds are top-notch. The combination of a mechanical shutter for traditional use and an incredibly fast electronic shutter with minimal distortion makes it highly versatile for various shooting situations. The 20fps continuous shooting speed with autofocus is perfect for capturing fast action, making the Z9 a powerful tool for professional photographers who need to freeze fleeting moments. If flash photography is a major part of your workflow, the Z9's flash sync speed might be a consideration, but otherwise, its shutter and shooting speed capabilities are impressive.

Viewfinder and LCD

The Nikon Z9 boasts a high-quality electronic viewfinder (EVF) and a tilting LCD screen, offering excellent image quality and flexibility for composing shots and image review. Here's a breakdown of both with images for reference:

Electronic Viewfinder (EVF)

- **Type:** OLED (Organic Light-Emitting Diode)
- **Resolution:** 3.69 million dots

- **Magnification:** 0.8x

- **Blackout-free view:** Ensures a smooth and uninterrupted viewing experience while shooting, especially helpful for fast-paced action or tracking moving subjects.

- **High refresh rate:** 120 fps refresh rate minimizes lag and provides a realistic view of the scene, crucial for critical focusing and composition.

- **Eye sensor:** Automatically switches between the EVF and the rear LCD screen based on your position.

LCD Screen

- **Size:** 3.2-inch touchscreen LCD

- **Resolution:** 2.1 million dots

- **Tilting mechanism:** A fully articulating tilting mechanism allows for comfortable viewing and composing from various angles, including high or low positions. This is beneficial for videography or shooting in awkward situations.

- **Touchscreen functionality:** The touchscreen can be used for various functions like navigating menus, selecting focus points, and image playback.

The combination of the high-resolution OLED EVF and the tilting LCD screen makes the Nikon Z9 a joy to use for both photography and videography. The EVF offers a clear and realistic view of the scene, while the tilting LCD provides flexibility and convenience for composing shots and reviewing images.

CHAPTER FOUR
ADVANCED IMAGING FEATURES

Autofocus System

The Nikon Z9 boasts a top-of-the-line autofocus system, making it a powerful tool for both photographers and videographers. Here's a comprehensive breakdown of the Z9's autofocus system, featuring an image for better understanding:

Hybrid AF System:

- The Z9 employs a hybrid autofocus system that combines two technologies:
 - **Phase-detect autofocus (PDAF):** This system uses dedicated sensors on the image sensor to detect phase differences of light rays from the subject, achieving very fast and accurate focus, especially for tracking moving objects.

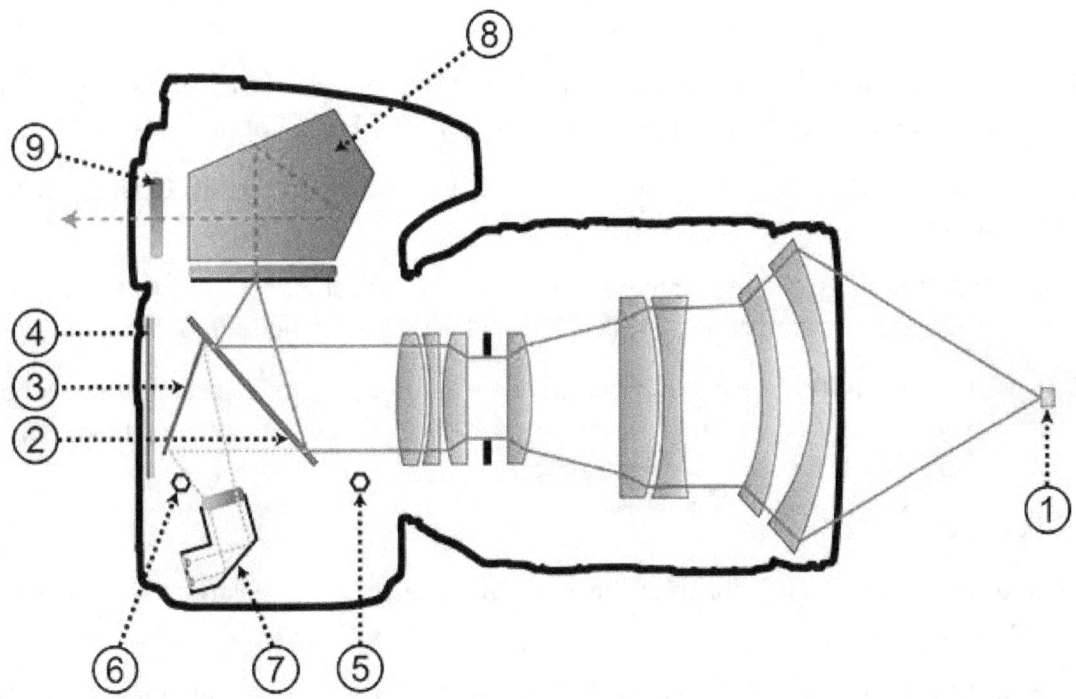

 - **Contrast-detect autofocus (CDAF):** The camera analyses the contrast between edges in different parts of the frame to achieve focus. CDAF is typically slower than PDAF but works well in low-light situations.
- The Z9's hybrid autofocus system leverages the strengths of both PDAF and CDAF to deliver fast, accurate, and reliable focusing performance in various lighting conditions and shooting scenarios.

Subject Detection Autofocus:

- The Z9 incorporates subject detection autofocus, which goes beyond basic focus and automatically recognizes and tracks various subjects. This simplifies focusing and ensures your desired subject stays sharp throughout your photos or videos.

- Detectable subjects include:
 - People (eyes, face, torso)
 - Animals (dogs, cats, birds, etc.)
 - Vehicles (cars, motorcycles)

- You can choose the specific subject type you want the camera to prioritize for autofocus through the camera menu.

Customizable Autofocus Settings:

The Z9 offers various customizable autofocus settings to tailor performance to your specific shooting needs:

- **AF modes:** Choose from autofocus modes like AF-S (Single AF) for static subjects, AF-C (Continuous AF) for tracking moving subjects, and Manual Focus for precise control.

- **AF area modes:** Select the area of the frame where the camera will focus. Options include single point, wide area, subject tracking, and more.

- **AF speed:** Adjust the speed at which the autofocus reacts to subject movement. A faster speed is ideal for tracking fast-paced action, while a slower speed can produce smoother focus transitions.

- **AF tracking sensitivity:** Control how sensitive the autofocus is to changes in subject position. A higher sensitivity allows the camera to track even slight movements, while a lower sensitivity is useful for maintaining focus on a locked subject.

Additional Features:

- **Eye-detection autofocus:** Prioritizes focusing on a subject's eye, ensuring sharp eye contact in your portraits.

- **Focus peaking:** Highlights in-focus areas of the frame to assist with manual focusing and achieving precise focus.

- **Focus button:** A programmable button allows you to temporarily switch to manual focus while shooting.

Benefits of the Z9's Autofocus System:

- **Fast and accurate autofocus:** The hybrid system delivers exceptional focusing speed and precision, ideal for capturing fast-moving subjects or critical moments.

- **Reliable performance:** The Z9's autofocus excels in various lighting conditions, from bright daylight to low-light environments.
- **Subject tracking:** The camera's ability to detect and track subjects simplifies focusing and ensures your main object stays in sharp focus.
- **Customization options:** The Z9 provides extensive control over autofocus behaviour, allowing you to fine-tune it for different shooting scenarios.

Understanding the Z9's autofocus system and its capabilities empowers you to capture sharp and captivating photos and videos with ease.

Image Stabilization

The Nikon Z9 is equipped with a powerful In-Body Image Stabilization (IBIS) system that helps counteract camera shake and produce sharper images, especially at slower shutter speeds or when shooting handheld. Here's a detailed explanation of the Z9's IBIS system with an image for better understanding:

Sensor-Shift Stabilization:

- Unlike lens-based stabilization systems, the Z9 utilizes sensor-shift image stabilization (IBIS).

- The camera's image sensor is physically moved on five axes (vertical, horizontal, and rotational) to compensate for camera shake during image capture.
- This method is effective for stabilizing various types of camera shake, including:
 - Angular shake (up/down and side-to-side movement)
 - Shift shake (sensor shifts parallel to the image plane)

CIPA Image Stabilization Rating:

- The Z9's IBIS system is rated for up to 6 stops of image stabilization according to CIPA (Camera & Imaging Products Association) standards. This means you can potentially use shutter speeds 6 stops slower than the recommended handheld shutter speed for your focal length and still capture sharp images.
- For instance, if the recommended handheld shutter speed for your lens and focal length at a specific aperture is 1/125s, the Z9's IBIS could allow you to achieve sharp images at a shutter speed as slow as 1/8s (6 stops slower).

Benefits of IBIS:

- **Sharper handheld photos:** IBIS allows you to shoot at slower shutter speeds while maintaining sharp images, even without a tripod. This is particularly beneficial in low-light situations where faster shutter speeds would require increasing ISO, which can introduce noise.
- **Improved video quality:** IBIS helps stabilize video footage, reducing camera shake and producing smoother, more professional-looking videos.
- **Versatility with different lenses:** IBIS works effectively with all compatible Nikon Z mount lenses, even those without built-in optical VR (Vibration Reduction).

Additional Considerations:

- The effectiveness of IBIS can vary depending on the shooting scenario and the amount of camera shake.
- IBIS might not completely eliminate blur caused by subject movement. For situations with moving subjects, you might still need to use a faster shutter speed.
- While IBIS offers significant advantages, using a tripod for maximum image sharpness is always recommended for critical shots.

Overall, the Z9's IBIS system is a valuable asset for photographers and videographers who want to capture sharp images and smooth videos in various lighting conditions and shooting situations.

High-Speed Shooting Modes

The Nikon Z9 excels in capturing fast-action moments with its high-speed shooting modes. Here's a breakdown of these modes to help you choose the right one for your needs:

Continuous Shooting Modes:

The Z9 offers two main continuous shooting modes for capturing bursts of images at high frame rates:

- **Continuous High-Speed (CH):** This mode prioritizes maximum frame rate for capturing fleeting moments of fast-action scenes. You can choose frame rates ranging from **20 frames per second (fps) to 10 fps**.
- **Continuous Low-Speed (CL):** This mode offers slower frame rates (ranging from **10 fps to 1 fps**) but allows you to capture a larger burst of images before the camera's buffer fills up.

Choosing the Right Mode:

The ideal mode depends on the speed of the action you're capturing and the desired number of frames in the burst:

- **For extremely fast-paced action:** Use CH mode at 20 fps to capture the peak moment of an action sequence with maximum detail. However, the burst length might be shorter due to the high frame rate.
- **For fast-moving subjects:** Choose CH mode at 10 fps for a good balance between frame rate and burst length, ideal for capturing sports or wildlife.
- **For slower action or longer sequences:** Opt for CL mode at a slower frame rate (e.g., 5 fps or 2 fps) to capture a more extended burst of images, useful for photographing events that unfold over a short period.

Additional Considerations:

- **File format:** High-speed shooting often utilizes JPEG format for faster processing. You might have limited RAW capture options in high-speed modes.
- **Focus tracking:** The Z9's autofocus system plays a crucial role in high-speed shooting. Ensure you choose the appropriate autofocus mode (e.g., AF-C) to track moving subjects effectively.
- **Memory card:** A fast UHS-II SD card or CFexpress Type B card is recommended for smooth burst shooting and faster image buffer clearing.

Beyond Frame Rate:

The Z9's high-speed shooting capabilities are enhanced by other features:

- **Blackout-free viewfinder:** Maintain a clear view of the subject even during high-speed bursts, allowing you to precisely track moving subjects.
- **Fast image processing:** The camera quickly processes captured images, minimizing shutter lag and allowing you to capture the decisive moment.

- **Large buffer:** The Z9 boasts a large buffer to store a significant number of images before slowing down, ensuring you capture crucial moments in a fast-evolving scene.

By understanding the Z9's high-speed shooting modes and their functionalities, you can effectively capture stunning images of fast-action subjects and fleeting moments.

Advanced Metering and Exposure

The Nikon Z9 provides advanced metering and exposure controls to achieve precise results in various lighting conditions. Here's a comprehensive dive into these functionalities:

Metering Modes:

The Z9 offers a selection of metering modes to determine the optimal exposure for your scene. Each mode analyses light distribution differently to achieve a balanced exposure:

- **Matrix Metering (Multi-segment):** This is the default mode and the most versatile option. The camera divides the frame into segments, analyses light in each area, and calculates an exposure that balances highlights and shadows for a natural-looking image.

- **Centre-Weighted Metering:** Prioritizes the exposure reading from the central portion of the frame, ideal for situations where your subject is centred and the background is less important.

- **Spot Metering:** Measures the light from a very small, user-selected area of the frame. This mode is useful for subjects with significantly different brightness levels compared to the background, such as a white bird against a dark sky.

- **Highlight-Weighted Metering:** Prioritizes preserving highlights in the scene, ensuring they don't get blown out (appear pure white with no detail). This mode is helpful for photographing scenes with bright elements like snow or wedding dresses.

Exposure Compensation:

Even with the chosen metering mode, you might want to fine-tune the exposure for creative purposes or challenging lighting conditions. The Z9 allows exposure compensation, letting you adjust the camera's recommended exposure value (often displayed as a +/- scale). For example, if the camera recommends a specific aperture and shutter speed combination but you want a slightly brighter image, you can adjust the exposure compensation value positively (e.g., +1/3 stop, +2/3 stop). Conversely, for a darker image, you would use a negative exposure compensation value.

Auto Exposure Lock (AE Lock):

This feature allows you to lock the exposure reading based on a specific area of the frame, even if you recompose the shot. This is helpful for situations where your subject isn't located in the canter of the frame and you want to ensure proper exposure for them regardless of the background light.

Advanced Exposure Controls:

The Z9 offers additional exposure controls for experienced photographers:

- **Histogram:** A graphical representation of the tonal distribution in your image, helping you identify potential exposure issues like blown-out highlights or underexposed shadows.
- **Exposure Bracketing:** Capture multiple frames of the same scene at different exposure values (e.g., one frame at the recommended exposure, one frame underexposed, and one frame overexposed). This bracketing ensures you have a higher chance of capturing an image with the desired exposure, especially in high-contrast scenes.
- **White Balance Adjustments:** Fine-tune the camera's white balance setting to achieve natural-looking colour reproduction under various lighting conditions (incandescent, fluorescent, daylight, etc.).

Understanding Exposure and Metering:

- **Exposure** refers to the total amount of light that reaches the camera sensor, determined by aperture (lens opening size), shutter speed (duration the shutter stays open), and ISO (sensor sensitivity).
- **Metering** is the process by which the camera measures light to determine the appropriate exposure settings.

Choosing the Right Metering Mode and Exposure Controls:

The optimal choice depends on the lighting situation and your creative intent:

- **For balanced exposure in most situations:** Use Matrix Metering.
- **For centred subjects or bright backgrounds:** Consider Centre-Weighted Metering.
- **For precise exposure control on specific areas:** Utilize Spot Metering.
- **For preserving highlights:** Choose Highlight-Weighted Metering.

Experiment with different metering modes and exposure adjustments to achieve the desired results in your photos. The Z9's advanced metering and exposure capabilities empower you to capture well-exposed images that reflect your creative vision.

Colour Science and Picture Profiles

The Nikon Z9 delivers exceptional colour science and a range of picture profiles, empowering you to achieve stunning visuals and creative control over your photos and videos. Here's a detailed explanation with an image for better understanding:

Nikon Colour Science:

- Renowned for natural colour reproduction, Nikon cameras capture colours that closely resemble real-world scenes.

- The Z9 inherits this tradition, ensuring your photos and videos boast rich tones, smooth colour transitions, and accurate representation of subjects.

Picture Profiles:
- Picture profiles are sets of pre-defined adjustments that influence various image characteristics upon in-camera processing, affecting the final look of your photos and videos. These profiles can modify:
 - **Saturation:** Controls the intensity and vibrancy of colours (e.g., increase saturation for richer colours or decrease it for a more muted look).
 - **Contrast:** Adjusts the difference between highlights (lightest areas) and shadows (darkest areas) in the image, impacting the overall depth and pop.
 - **Sharpness:** Enhances or softens the definition of edges in your photos, affecting perceived clarity and detail.
 - **Colour Tone:** Shifts the overall colour temperature, creating a warmer or cooler image aesthetic (e.g., warmer tones for a nostalgic feel or cooler tones for a modern look).
- The Z9 provides a variety of built-in picture profiles to suit different creative goals:
 - **Standard:** A versatile profile delivering a natural and balanced look, perfect for various shooting scenarios.
 - **Neutral:** Provides a flat colour palette, ideal for photographers who prefer minimal colour manipulation and extensive post-production editing.
 - **Portrait:** Emphasizes smooth skin tones and pleasing colours, flattering for portrait photography.
 - **Landscape:** Enhances vibrancy and saturation for a more dramatic impact in landscape shots.
 - **Creative profiles:** Offer artistic effects like black and white or vintage tones.

Choosing the Right Picture Profile:
- The ideal profile depends on your creative vision and desired outcome:
 - **For true-to-life colours:** Utilize the Standard profile.
 - **For maximum editing flexibility in post-production:** Choose the Neutral profile.
 - **For flattering portraits:** Opt for the Portrait profile.
 - **For landscapes with a vivid look:** Select the Landscape profile.
 - **For artistic expression:** Experiment with creative profiles.

- You can also create and save custom picture profiles on the Z9 to achieve a signature look for your photos and videos.

Additional Considerations:

- Picture profiles primarily affect JPEG images processed in-camera. They have a minimal impact on RAW files, which capture the most image data and offer the most flexibility for adjustments during post-production editing.
- The Z9 allows fine-tuning the parameters of most picture profiles, providing some level of customization within each preset.

Understanding Colour Science and Picture Profiles:

- **Colour science** refers to the camera's technology and algorithms responsible for capturing and processing colour information.
- **Picture profiles** are a collection of pre-defined adjustments applied to the captured colours to achieve various creative looks.

By mastering the Z9's colour science and picture profiles, you can capture captivating visuals that reflect your creative vision and optimize your workflow for post-production editing.

CHAPTER FIVE
VIDEO CAPABILITIES

Video Recording Resolutions and Frame Rates

The Nikon Z9 boasts impressive video recording capabilities, offering a variety of resolutions and frame rates to suit different creative needs. Here's a breakdown of the Z9's video recording options:

Video Resolutions:

- **8K UHD (7680 x 4320):** This is the highest resolution available on the Z9, offering stunning detail and ideal for professional videographers or those who want the ultimate image quality.

Class / Format	8K and 6K Input ERP Resolution				4K Input ERP Resolution			
	faceW	faceH	W	H	faceW	faceH	W	H
ERP (coded)	4096	2048	4096	2048	3328	1664	3328	1664
Padded ERP	4096	2048	4112	2048	3328	1664	3344	1664
CISP	952	824	2496	3320	776	672	2056	2712
CMP compact	1184	1184	3552	2368	960	960	2880	1920
COHP	1552	1344	2688	3144	1256	1088	2176	2552
SSP	1184	1184	1184	7136	960	960	960	5792
AEP	4096	2048	4096	2048	3328	1664	3328	1664
ACP	1184	1184	3552	2368	960	960	2880	1920
RSP	1184	1184	3552	2368	960	960	2880	1920
EAC	1184	1184	3552	2368	960	960	2880	1920
ECP	1184	1184	3552	2368	960	960	2880	1920

- **4K UHD (3840 x 2160):** A popular choice for professional and enthusiast videographers, 4K UHD provides excellent image quality with a good balance between resolution and file size.

- **Full HD (1920 x 1080):** A widely used resolution suitable for various applications, including online sharing, social media, and less demanding productions.

Frame Rates:

The Z9 offers a wide range of frame rates for each resolution, allowing you to capture slow-motion or fast-paced action with smooth playback. Here's a table summarizing the available frame rates for each resolution:

Resolution	Frame Rates (fps)
8K UHD	30p, 25p, 24p
4K UHD	120p, 100p, 60p, 50p, 30p, 25p, 24p
Full HD	120p, 100p, 60p, 50p, 30p, 25p, 24p

Choosing the Right Resolution and Frame Rate:

The ideal resolution and frame rate depend on your specific needs:

- **For professional productions or maximum image quality:** Choose 8K resolution with a frame rate of 30p.

- **For high-quality videos with smooth motion:** Opt for 4K UHD at 60p or higher frame rates. This is suitable for capturing fast-paced action or creating slow-motion effects in post-production.

- **For online sharing or social media:** 4K UHD at 30p or Full HD at various frame rates are good options, providing a good balance between quality and file size.

- **For creating slow-motion effects:** Utilize high frame rates like 120p or 100p in 4K or Full HD resolutions. However, be aware that slow-motion effects will result in slower playback speeds and larger file sizes.

Additional Considerations:

- **Higher resolutions and frame rates require faster memory cards:** UHS-II SD cards or CFexpress Type B cards are recommended for smooth recording at high bitrates.

- **Higher resolutions and frame rates produce larger video files:** This requires more storage space and might impact editing performance on less powerful computers.

By understanding the Z9's video recording resolutions and frame rates, you can choose the settings that best suit your project requirements and achieve stunning visuals for your video productions.

Autofocus in Video Mode

The Nikon Z9 shines in video mode with its advanced autofocus system, offering several features to track your subjects and maintain focus throughout your recording. Here's a breakdown of the Z9's autofocus capabilities in video mode, complete with images for better understanding:

Autofocus Modes:

The Z9 provides various autofocus modes to cater to different shooting scenarios in video:

- **AF-F (Full-time AF):** This is the default mode and continuously adjusts focus to maintain sharpness on your subject. It's ideal for most video recording situations.

- **AF-S (Single AF):** Focus is locked on the subject you select and only adjusts if you manually refocus. This mode is useful for static shots or when you want to control focus transitions precisely.

- **MF (Manual Focus):** You manually control the focus ring on the lens to achieve sharp images. This mode offers the most creative control over focus but requires practice for smooth focusing while recording.

Subject Detection:

The Z9 incorporates subject detection autofocus, which automatically recognizes and tracks various subjects. This simplifies focusing on people, animals, or vehicles in your video. You can choose from options like:

- **Eye-detection AF:** This mode prioritizes focusing on a subject's eye, ensuring sharp eye contact in your videos.

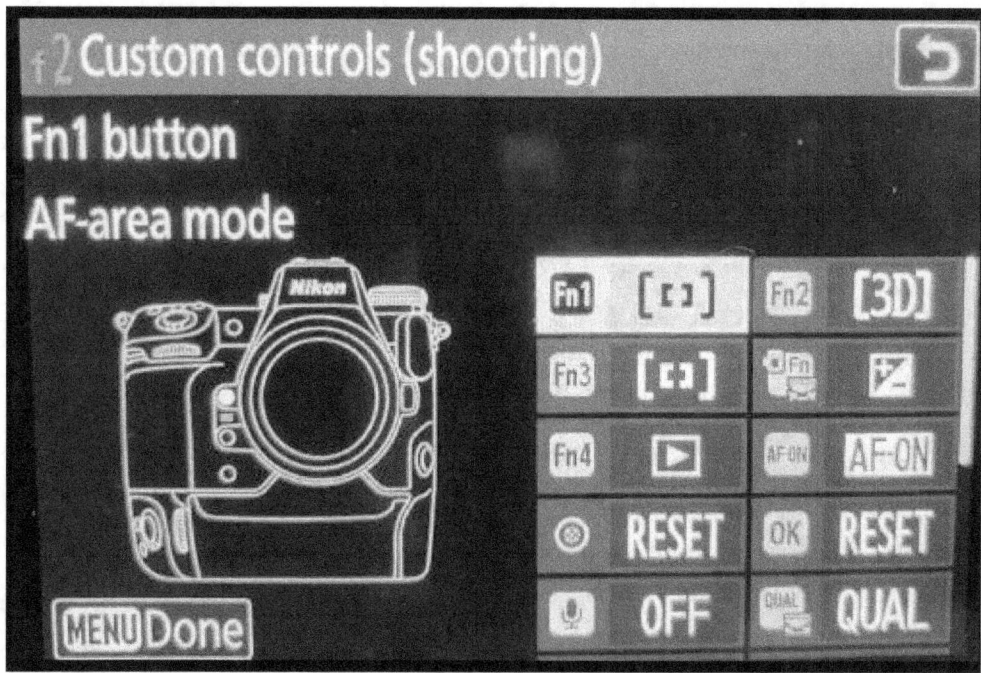

- **Animal-detection AF:** The camera automatically detects and tracks animals, making it ideal for wildlife videography.

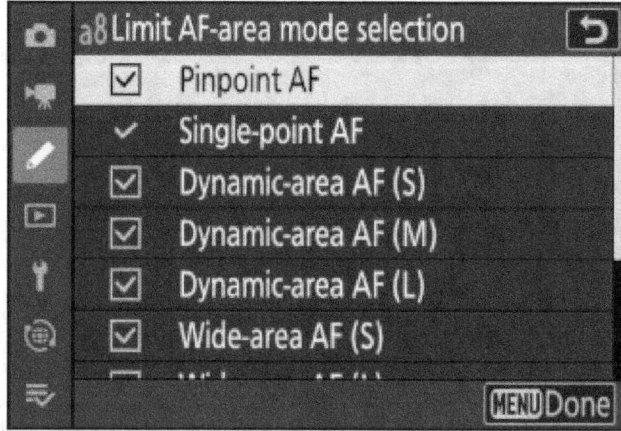

- **Vehicle-detection AF:** Tracks moving vehicles, helpful for capturing car races or other scenarios with moving vehicles.

Customizing Autofocus:

The Z9 allows customization of autofocus behaviour for video recording:

- **AF Speed:** Adjust the speed at which the autofocus reacts to subject movement. A faster speed is ideal for tracking fast-paced action, while a slower speed can produce smoother focus transitions.
- **AF Tracking Sensitivity:** This controls how sensitive the autofocus is to changes in subject position. A higher sensitivity allows the camera to track even slight movements, while a lower sensitivity is useful for maintaining focus on a locked subject.

Using the Focus Button:

The Z9 features a programmable focus button (often labelled "AF-ON") that allows you to temporarily switch to manual focus while recording. This is helpful for critical focus adjustments or creative rack focus techniques.

Focus Peaking:

Enable focus peaking to highlight in-focus areas of your frame. This is a visual aid that assists with manual focusing and achieving precise focus during video recording.

Additional Tips:

- Utilize the touchscreen LCD or joystick to select your focus point for better control over subject tracking.
- Experiment with different autofocus modes and settings to find what works best for your specific video projects.
- Ensure your lens is compatible with autofocus in video mode. Some older lenses might not support all autofocus features.

By understanding the Z9's autofocus capabilities in video mode, you can leverage its advanced features to capture sharp and captivating videos with smooth focus transitions.

Audio Recording Options

The Nikon Z9 offers several audio recording options to capture high-quality sound for your videos. Here's a detailed explanation with images to help you choose the best setup for your needs:

Built-in Stereo Microphone:

- The Z9 features a built-in stereo microphone that captures basic audio for casual videos or situations where external microphones are impractical.

- The audio quality is acceptable but might lack directionality and pick up unwanted ambient noise.

External Microphone Jack:

- The Z9 provides a 3.5mm stereo mini-jack microphone input for connecting external microphones. This allows you to significantly improve the audio quality of your videos.

- You can use various external microphones depending on your needs:
 - **Shotgun microphones:** Ideal for capturing clear, directional audio from your subject, minimizing background noise.

- **Lavalier microphones:** Small microphones that can be clipped onto your subject's clothing for discreet audio recording.

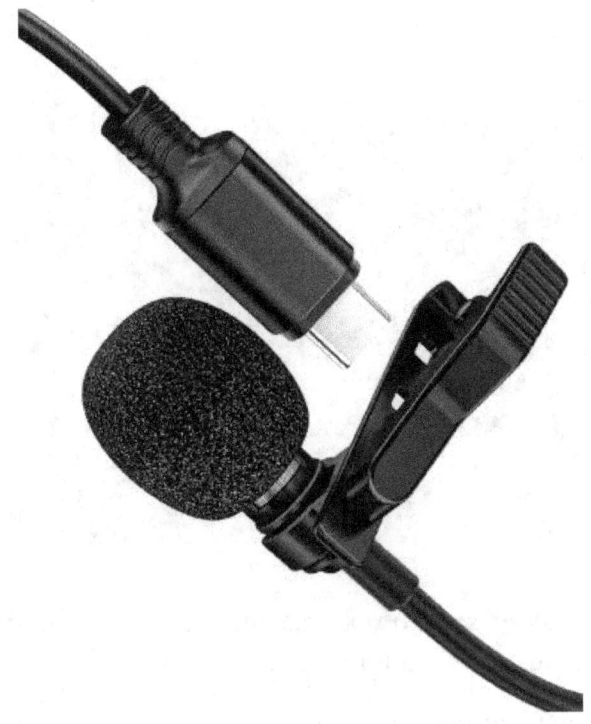

- **Wireless microphones:** Offer more freedom of movement for your subject while recording audio.

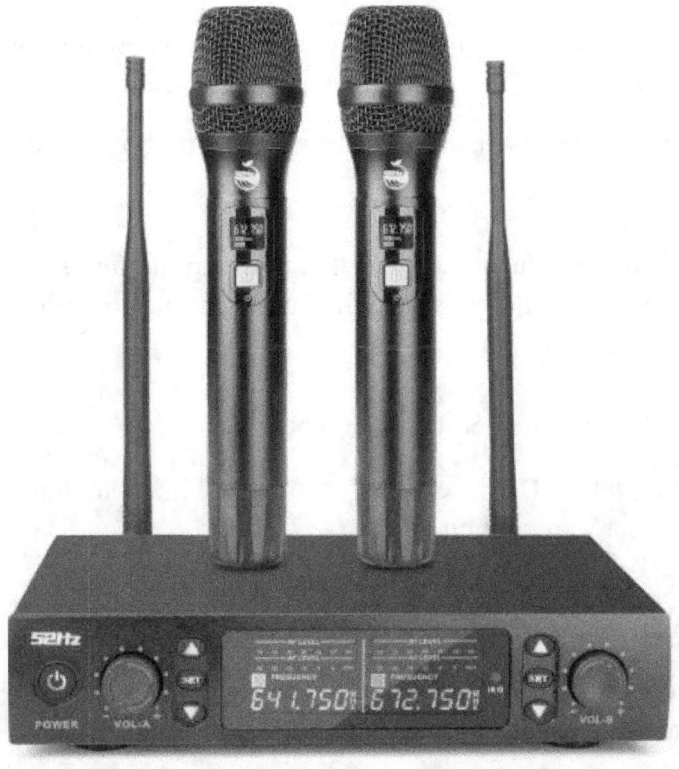

Microphone Power

- The Z9 menu allows you to choose whether to supply power to the external microphone through the camera (Mic jack plug-in power).

- **Camera-powered microphones:** Some external microphones are designed to draw power directly from the camera, eliminating the need for separate batteries.

- **Externally powered microphones:** Higher-end microphones might require their own battery source for operation.

Audio Level Control

- The Z9 provides manual audio level control to adjust the recording volume of the microphone. This helps prevent audio clipping (distortion) and ensures your audio levels are appropriate.

- You can monitor the audio levels visually on the camera's display while recording.

Wind Noise Reduction

- The Z9 offers a wind noise reduction setting that can help minimize wind noise when recording outdoors. This feature is particularly useful when using the built-in microphone.

Choosing the Right Audio Setup:

- **For casual videos:** The built-in microphone might suffice.

- **For improved audio quality:** Use an external microphone like a shotgun mic for directional audio or a lavalier mic for discreet recording.

- **For maximum flexibility:** Consider a wireless microphone system for increased freedom of movement while recording sound.

- **Professional videography:** External microphones with separate battery power and manual controls often provide the best audio quality.

Additional Tips:

- Invest in a furry windjammer for your external microphone if you frequently shoot outdoors. This helps reduce wind noise significantly.

- Use a recorder to capture high-quality audio separately from your video, especially for critical projects. This allows for more precise control over audio levels and editing in post-production.

By understanding the Z9's audio recording options and choosing the right setup, you can ensure your videos have clear and professional-sounding audio that complements your visuals.

Log Profiles and HDR

The Nikon Z9 offers functionalities to capture video with a wider dynamic range and colour flexibility: Log profiles and HDR (High Dynamic Range).

Here's a breakdown of how these modes work and when to use them:

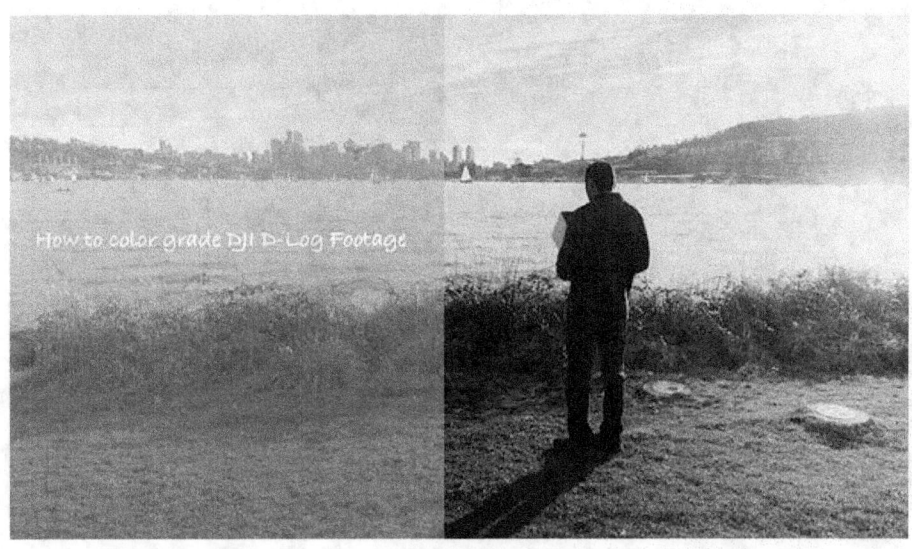

Log Profiles:

- Log profiles capture a wider range of tones and colours compared to standard video profiles. They appear flat and desaturated upon recording, requiring post-production colour grading to achieve the final look.

- **Benefits:**
 - Preserve highlights and shadows: Log profiles prevent detail loss in the brightest and darkest parts of the image, offering more flexibility for colour correction in post.
 - More colour grading control: The flat image captured by log profiles allows for greater creative control over colour manipulation and achieving specific looks during editing.

- **Drawbacks:**
 - Require colour grading expertise: Log footage needs colour grading to produce a natural-looking final video. This can be time-consuming and requires knowledge of colour correction techniques.
 - Larger file sizes: Log files tend to be larger than standard video profiles due to the wider range of tonal information captured.

HDR (High Dynamic Range):

- HDR video captures a wider dynamic range than standard video by combining multiple exposures into a single image. This results in videos with more realistic contrast and detail in both highlights and shadows.

- **Benefits:**
 - Realistic reproduction of scenes with high contrast: HDR video excels at capturing scenes with bright highlights and dark shadows, offering a more natural and immersive viewing experience.
 - No need for colour grading (optional): HDR video can be used directly without extensive colour grading, although some post-production adjustments might still be desired.
- **Drawbacks:**
 - Requires compatible display technology: To fully appreciate the benefits of HDR, you need a display that supports HDR playback.
 - Potentially more demanding workflow: HDR editing might require additional processing power and software capabilities compared to editing standard video.

Choosing Between Log Profiles and HDR:

- **Use log profiles when:**
 - You need maximum control over colour grading and achieving a specific creative look in post-production.
 - You plan on heavy colour correction and adjustments during editing.
- **Use HDR when:**
 - You want a more natural and realistic reproduction of high-contrast scenes.
 - You plan on using the footage directly without extensive colour grading.
 - You have a post-production workflow and display technology that supports HDR.

Additional Considerations:

- The Z9 might offer different variations of log profiles, each with slightly different characteristics. Consult your camera manual to understand the specific options available and their creative applications.
- Experiment with both log profiles and HDR to see which workflow best suits your needs and editing skills.

By understanding the capabilities of log profiles and HDR on the Z9, you can choose the most suitable recording mode to capture videos with stunning visuals and flexibility for post-production.

Slow Motion and Time-Lapse

The Nikon Z9 caters to both slow-motion and time-lapse videography, allowing you to capture the world in a unique way. Here's a breakdown of these functionalities:

Slow Motion:

- The Z9 offers two ways to achieve slow-motion effects:
 - **Dedicated Slow-Motion Modes:** The camera features dedicated slow-motion video modes at specific resolutions and frame rates. These modes capture footage at high frame rates (e.g., 120 fps, 240 fps) and play them back at standard frame rates (e.g., 30 fps, 24 fps). This stretches the time duration, resulting in a slow-motion effect. However, recording times might be limited in these modes.

- **High Frame Rate Recording:** You can record regular video at high frame rates (available up to 120 fps in 4K and Full HD) and slow down the footage during editing in post-production software. This method offers more flexibility in playback speeds but requires powerful editing software for smooth slow-motion results.

Using Dedicated Slow-Motion Modes:

- The Z9's slow-motion modes are available in the video recording menu. They typically offer options like 1080p at 120 fps (plays back at 30 fps) or 1080p at 240 fps (plays back at 24 fps).

- **Advantages:**
 - Easy to use: Simply select the dedicated slow-motion mode and start recording. No need for additional settings or post-production adjustments.
 - Fast results: You can see the slow-motion effect immediately during playback on the camera.

- **Limitations:**
 - Limited resolution and frame rates: Slow-motion modes are usually restricted to Full HD resolution and might not offer the highest frame rates available on the Z9.
 - Shorter recording times: Recording durations might be shorter in slow-motion modes compared to standard video recording.

Using High Frame Rate Recording:

- Choose a high frame rate option (e.g., 120 fps) in the regular video recording menu for your desired resolution (4K or Full HD).

- Record your video footage normally.

- During post-production editing, slow down the footage playback speed to achieve the slow-motion effect. Most editing software allows you to adjust playback speed to create slow motion.

- **Advantages:** * More flexibility and control: You can choose any playback speed for the slow-motion effect in editing, offering more creative control. * Higher potential quality: Utilize the Z9's full range of resolutions and frame rates for potentially smoother and higher-quality slow motion in post.

- **Limitations:** * Requires post-production editing: You need editing software capable of slowing down video playback to achieve the slow-motion effect. * Processing power demands: Slowing down high frame rate footage during editing can be demanding on your computer's processing power.

Time-Lapse:

- The Z9 features a built-in time-lapse mode that captures photos at specific intervals and compiles them into a video, creating a sped-up version of a scene unfolding over time.

- **Using the Time-Lapse Mode:**
 - Access the time-lapse mode in the camera menu.
 - You can set various parameters like:
 - Interval: The time between capturing individual photos (e.g., 1 second, 5 seconds, 1 minute). Shorter intervals create smoother time-lapse videos but result in larger file sizes.
 - Shooting duration: The total recording time for the time-lapse sequence.
 - Picture size: Choose the resolution of the captured photos for the time-lapse video.

- **Benefits:** * Easy to use: The built-in time-lapse mode simplifies capturing time-lapse videos without needing external software. * In-camera preview: The camera provides a preview of the playback speed of your time-lapse video.

- **Limitations:** * Less customization compared to external software: The built-in mode might offer fewer customization options than dedicated time-lapse software. * Larger file sizes: Time-lapse videos can generate large files due to the numerous photos captured.

Choosing Between Slow-Motion and Time-Lapse:

- Use slow motion to capture fleeting moments and emphasize specific actions in detail at a slower pace.

- Use time-lapse to condense lengthy events into a short video, showcasing changes happening over time in a sped-up manner.

Additional Tips:

- Experiment with different frame rates, intervals, and playback speeds to achieve the desired slow-motion or time-lapse effect.

Use a stable tripod for both slow-motion and time-lapse recording to minimize camera shake.

CHAPTER SIX
CONNECTIVITY AND STORAGE

Wireless and Wired Connectivity

The Nikon Z9 offers a variety of options for connecting wirelessly and wired to other devices, providing flexibility for image transfer, remote shooting, and other functionalities. Here's a breakdown of the Z9's wireless and wired connectivity features:

Wireless Connectivity:

- **SnapBridge App:** The Z9 connects to your smartphone or tablet via the Nikon SnapBridge app. This app allows you to:
 - **Transfer Images:** Wireless transfer of photos and videos from the camera to your smart device for easy sharing on social media or backup purposes.
 - **Remote Shooting:** Control the camera remotely from your smartphone using the app. This can be useful for capturing self-portraits, group photos, or wildlife shots where you need to minimize camera shake.
 - **Image Review:** Browse and review images captured on the Z9 directly on your smartphone or tablet.

- **Wi-Fi Connectivity:** The Z9 allows for connecting directly to a Wi-Fi network. This enables:
 - **FTP Transfer:** Transfer images directly from the camera to an FTP server for secure backup or sharing with clients.
 - **Computer Tethering:** Connect the Z9 to your computer wirelessly for tethered shooting, allowing you to view the live feed on your computer screen and control camera settings remotely.

Wired Connectivity:

- **USB-C Port:** The Z9 features a USB-C port that provides several functionalities:
 - **Tethered Shooting:** Connect the camera directly to your computer using a USB-C cable for tethered shooting with a more stable connection compared to Wi-Fi.
 - **Charging:** The Z9 can be charged using a USB-C cable and a compatible power source (USB-C wall charger or power bank). However, Nikon recommends using the in-camera charging method for faster and more reliable charging.
 - **Data Transfer:** Transfer photos and videos directly from the camera to your computer for storage and editing.

Choosing the Right Connection Method:

The best connection method depends on your specific needs:

- **For casual image sharing and remote shooting:** The SnapBridge app is a convenient option for quick transfers and basic remote control.

- **For secure backups or professional workflows:** Wi-Fi connection with FTP transfer or computer tethering offers a more robust solution for critical photos.

- **For the most stable tethered shooting experience:** A wired USB-C connection provides the most stable and reliable connection for tethered shooting.

- **For on-the-go charging:** While slower than in-camera charging, a USB-C cable and power bank can be a lifesaver for extending battery life while traveling.

Additional Considerations:

- **Wireless connectivity might be slower than wired options.**

- **Using Wi-Fi or Bluetooth can drain the battery faster.**

- **Ensure your devices and software are compatible with the Z9's wireless features.**

By understanding the Z9's wireless and wired connectivity options, you can choose the most appropriate method for your workflow and maximize your camera's capabilities.

Dual Card Slots and File Management

The Nikon Z9 boasts dual card slots, a valuable feature for professional photographers and anyone who prioritizes image safety and organization. Here's a detailed explanation of the Z9's dual card slots and file management options:

Benefits of Dual Card Slots:

- **Backup:** The primary benefit of dual card slots is redundancy. You can record images simultaneously on two separate memory cards. This provides a safety net in case one card malfunctions or gets corrupted, ensuring you don't lose your precious photos.

- **Increased Storage Capacity:** If you use high-resolution settings or shoot long sessions, dual cards allow you to extend your total recording time before needing to swap cards.

- **Workflow Separation:** You can configure the card slots for different purposes. For example, use one card for RAW images for professional editing and another card for JPEGs for faster sharing or backups.

Understanding the Z9's Card Slots:

The Z CFexpress Type B card slot is the primary slot and supports the fastest transfer speeds. The secondary slot is an SD UHS-II slot and offers good performance but might not be as fast as the CFexpress slot.

File Management Options (Role Played by Card in Slot 2):

The Z9 menu allows you to configure how the camera utilizes the second card slot. Here are the different options:

- **Overflow (P):** This is the default setting. The camera starts recording to card 1 and switches to card 2 only when card 1 is full.

- **Backup (Q):** Every image captured is saved simultaneously on both cards. This is the safest option but consumes double the storage space.

- **RAW Slot 1 - JPEG Slot 2 (R):** RAW (uncompressed) images are saved on card 1, while compressed JPEG copies are saved on card 2. This allows you to maintain high-quality RAW files for editing while having readily shareable JPEGs. (Note: In image quality settings other than RAW + JPEG, this option functions the same as Backup (Q).)

- **JPEG Slot 1 - JPEG Slot 2 (O):** Two JPEG copies are saved, one on each card. You can choose the image quality for the card 1 JPEG (controlled by the shooting menu or T button), while the card 2 JPEG is saved at a basic quality and medium size.

Choosing the Right File Management Option:

The ideal file management option depends on your needs:

- **Prioritize safety:** Choose Backup (Q) for maximum redundancy.

- **Balance quality and shareability:** Use RAW Slot 1 - JPEG Slot 2 (R) to maintain RAW files and have quick-sharing JPEGs.

- **Extend storage for JPEGs:** Opt for JPEG Slot 1 - JPEG Slot 2 (O) if you primarily shoot JPEGs and need more storage capacity.

Additional Tips:

- Use high-quality memory cards from reputable brands to ensure reliability and performance.

- Format your memory cards regularly in the camera for optimal performance.

- Consider labelling your memory cards for easier organization, especially when using them for different purposes.

- Regularly back up your captured images to a computer or external storage device for additional security.

By effectively utilizing the Z9's dual card slots and file management options, you can ensure your photos are safe, organized, and readily accessible for editing, sharing, or future reference.

Remote Control and Tethering

The Nikon Z9 offers advanced capabilities for remote control and tethering, catering to professional photographers and videographers who require efficient workflows and flexible shooting options. These features allow users to control the camera remotely, transfer images instantly, and manage settings without physically handling the camera. Here's a detailed look at how the Nikon Z9 supports remote control and tethering:

Remote Control Options

1. Nikon SnapBridge

Functionality:

- **Remote Shooting:** SnapBridge allows you to control the Z9 remotely via a smartphone or tablet. This includes live view display, shutter release, and basic camera settings adjustments.
- **Image Transfer:** SnapBridge supports the automatic transfer of images from the camera to your mobile device. You can also select specific images to transfer manually.

Connectivity:

- **Bluetooth:** For continuous low-energy connections, which are sufficient for remote shooting and basic image transfer.
- **Wi-Fi:** For high-speed image transfer and more advanced remote control features.

Use Cases:

- **Social Media Sharing:** Quickly transfer images to your mobile device for immediate sharing on social media or emailing to clients.
- **Remote Shooting:** Ideal for situations where you cannot be physically present next to the camera, such as wildlife photography or self-portraits.

2. Nikon Wireless Remote Control (WR-R11a/WR-T10)

Functionality:

- **Shutter Release:** The WR-R11a and WR-T10 enable wireless remote shutter release, providing flexibility in shooting angles and camera placement.
- **Extended Range:** The system works over distances of up to 66 feet (20 meters), making it suitable for capturing shots from a distance without disturbing the subject.

Compatibility:

- **Nikon WR-R11a:** Acts as a transceiver that attaches to the Z9.

- **Nikon WR-T10:** A separate transmitter that you use to control the camera.

Use Cases:

- **Group Photography:** Useful for group shots where the photographer also wants to be in the picture.
- **Long Exposure:** Ideal for minimizing camera shake during long exposures, such as night photography or astrophotography.

3. Nikon Wireless Remote Control (WR-1)
Functionality:

- **Advanced Remote Control:** Offers more comprehensive control over camera settings and functions, including shooting modes and interval timer photography.
- **Extended Range:** Capable of controlling the camera from up to 394 feet (120 meters) away, suitable for long-range applications.

Use Cases:

- **Remote Wildlife Photography:** Enables photographers to capture images from a significant distance without disturbing wildlife.
- **Remote Event Photography:** Allows photographers to capture images from various angles during events without being in the midst of the action.

4. Third-Party Remote-Control Solutions
Wireless Solutions:

- **CamRanger:** Provides extensive remote-control options, including focus stacking, HDR, and live view functionality.
- **Tether Tools Air Direct:** Offers wireless tethering with a comprehensive suite of remote control features.

Wired Solutions:

- **TetherPro Cable:** Allows for direct connection between the camera and a computer for remote control and tethering without relying on wireless connections.

Use Cases:

- **Studio Photography:** Ideal for situations where immediate image review on a large screen is required, such as fashion or product photography.
- **On-Location Shoots:** Provides flexibility in camera positioning and control when working on location.

Tethering Options

1. Wired Tethering

USB-C Connection

- **Functionality:** The Nikon Z9 supports tethering via a USB-C connection, which allows for fast data transfer and reliable communication with a computer.
- **Software Compatibility:** Works with tethering software such as Adobe Lightroom, Capture One, and Nikon's own Camera Control Pro 2.
- **Image Transfer:** Enables immediate transfer of images to a computer for real-time viewing and editing.

Use Cases:

- **Studio Photography:** Ensures images are immediately available for review, reducing the need for back-and-forth between the camera and computer.
- **Product Photography:** Provides a seamless workflow for capturing and processing high-resolution product images.

2. Wireless Tethering

Wi-Fi Connection

- **Functionality:** The Z9 can connect to a computer or mobile device via Wi-Fi for wireless tethering, eliminating the need for cables and allowing for more flexible camera placement.
- **Software Compatibility:** Compatible with third-party applications like Capture One, which supports wireless tethering.

Use Cases:

- **On-Location Shoots:** Ideal for locations where cables may be impractical or pose a tripping hazard.
- **Event Photography:** Allows for quick transfer and review of images without the need for a wired connection.

Using Nikon's WT-6A Wireless Transmitter

- **Functionality:** The WT-6A provides a stable and fast wireless connection for image transfer and remote camera control.
- **Extended Range:** Offers a more robust and extended range compared to built-in Wi-Fi, making it suitable for large venues or outdoor shoots.

3. Ethernet Tethering
LAN Port

- **Functionality:** The built-in Ethernet port allows for tethering over a wired network connection, offering high-speed and reliable data transfer.
- **Software Compatibility:** Works with software like Nikon's Camera Control Pro 2, which allows for comprehensive remote camera control and image transfer.

Use Cases:

- **Sports Photography:** Enables immediate image transfer to editors for real-time processing during events.
- **Studio Environment:** Provides a stable and fast connection in a controlled environment, minimizing the risk of wireless interference.

4. Third-Party Tethering Solutions
Tether Tools Air Direct

- **Functionality:** Provides wireless tethering capabilities, allowing for control of camera settings and transfer of images to a computer or tablet.
- **Compatibility:** Works with a range of tethering software, providing flexibility and advanced features.

CamRanger

- **Functionality:** Offers comprehensive remote control and tethering options, including live view, focus adjustments, and advanced shooting modes.
- **Compatibility:** Supports a variety of software applications for enhanced functionality.

Software for Remote Control and Tethering
1. Nikon Camera Control Pro 2
Features:

- **Live View Control:** Enables live view shooting from a computer, providing a real-time feed from the camera.
- **Full Camera Control:** Allows adjustment of settings such as aperture, shutter speed, ISO, and more.
- **Image Transfer:** Supports the transfer of images directly to a computer for immediate review and editing.

2. Capture One
Features:

- **Tethered Shooting:** Provides robust tethering support with advanced features like live view, remote control, and immediate image review.

- **Editing Tools:** Offers comprehensive editing tools, making it a preferred choice for professional photographers.

3. Adobe Lightroom Classic
Features:

- **Basic Tethering:** Supports tethered shooting with the ability to adjust basic camera settings and transfer images directly into the Lightroom catalogue.

- **Editing Workflow:** Integrates seamlessly into the Adobe ecosystem for a streamlined editing workflow.

The Nikon Z9 offers a wide array of remote control and tethering options that cater to both studio and on-location photography. Whether you need wired or wireless connectivity, the Z9 provides robust solutions for efficient workflows, making it a versatile tool for professional photographers and videographers. These features ensure that users can manage their camera settings, transfer images, and review their work quickly and effectively, regardless of the shooting environment.

Firmware Updates

The Nikon Z9 receives firmware updates to improve functionality, fix bugs, and sometimes introduce new features. Here's how to keep your Z9 firmware up-to-date:

Nikon Download Centre:

1. Visit the Nikon Download Centre website:

2. Select your region (country/area) from the dropdown menu.

3. Click on "Products".

4. Under "Mirrorless Cameras", find and click on "Z 9".

5. You'll see a list of downloadable resources for the Z9, including firmware updates. Look for the section titled "Firmware".

6. The latest firmware version will be displayed. You'll also find information about the update, including a changelog that details the improvements or fixes addressed in the update.

7. Download the firmware update file (usually a .BIN file) to your computer.

Updating the Firmware:

1. **Before updating:** It's recommended to fully charge your Z9 battery and format a memory card in the camera. Also, make sure the memory card has enough free space to store the update file.

2. **Refer to your camera manual:** The specific instructions for installing firmware updates might vary slightly depending on your camera model. Consult your Z9 manual for detailed instructions on the update process. In general, the process involves copying the downloaded firmware file to a formatted memory card, inserting the card into the camera, and navigating the camera menu to select the firmware update option.

3. **Follow the on-screen instructions:** The camera will guide you through the update process, which typically involves restarting the camera several times.

4. **Do not turn off the camera:** It's crucial to avoid turning off the camera or removing the battery during the update process. This could potentially damage your camera.

5. **Verify the update:** Once the update is complete, the camera will usually display a confirmation message. You can also check the firmware version in the camera menu to ensure the update was successful.

Benefits of Keeping Firmware Updated:

- **Improved Performance:** Firmware updates can address bugs that might be affecting camera performance, such as autofocus accuracy, image quality, or overall stability.

- **New Features:** In some cases, firmware updates might introduce new features or functionalities for your camera.

- **Security Updates:** Firmware updates can also include security patches to address potential vulnerabilities in the camera's software.

Additional Tips:

- **Check for updates regularly:** Nikon periodically releases new firmware updates for the Z9. It's a good practice to check the Nikon Download Centre website periodically for the latest updates.

- **Only use official firmware:** Make sure you download the firmware update from the official Nikon website. Downloading firmware from unverified sources can be risky and potentially harm your camera.

By keeping your Z9 firmware updated, you can ensure your camera is operating at its best performance level, has the latest features, and benefits from any security improvements.

CHAPTER SEVEN
BATTERY AND POWER MANAGEMENT

Battery Life and Performance

The Nikon Z9's battery life is a bit of a mixed bag. CIPA (Camera & Imaging Products Association) ratings estimate the Z9 can capture around **440 shots** on a single charge. However, real-world results can vary depending on several factors:

- **Shooting Mode:** Using the viewfinder or rear LCD screen heavily will drain the battery faster.
- **Focus Mode:** Continuous autofocus consumes more power compared to single autofocus.
- **Video Recording:** Video recording, especially high-resolution formats, is much more demanding on the battery than still photography.
- **Wireless Connectivity:** Using Wi-Fi or Bluetooth to connect your camera to your smartphone or other devices will also drain the battery more quickly.
- **Temperature:** Battery life tends to decrease in colder temperatures.

Here's a comparison of battery life between the Z9 and some competitor cameras:

- **Canon EOS R5:** 490 shots (CIPA)
- **Sony a7 IV:** 580 shots (CIPA)
- **Nikon Z7 II:** 440 shots (CIPA)

Tips for Extending Battery Life:

- **Turn off the camera when not in use.**
- **Minimize use of the viewfinder and rely on the LCD screen when possible.**
- **Use single-point autofocus instead of continuous autofocus when appropriate.**
- **Limit video recording or use lower resolutions if battery life is a concern.**
- **Disable Wi-Fi and Bluetooth when not in use.**
- **Carry a spare battery, especially for long shooting sessions or travel.**

Overall Performance:

Despite the average battery life, the Z9 boasts excellent performance in other areas:

- **Fast and Accurate Autofocus:** The Z9's autofocus system is considered one of the best in the market, capable of tracking fast-moving subjects with exceptional accuracy.
- **High-Speed Continuous Shooting:** The Z9 can capture images at up to 20 frames per second with full autofocus and auto-exposure, ideal for action photography.

- **High-Resolution Sensor:** The Z9's 45.7MP full-frame sensor delivers stunning image quality with incredible detail and low-light performance.

- **8K Video Recording:** The Z9 offers professional-grade 8K video recording capabilities, making it a compelling option for videographers.

In conclusion, while the Z9's battery life might not be the best in its class, its overall performance and feature set make it a powerful and versatile camera for professional photographers and videographers. By implementing battery-saving practices and carrying a spare battery, you can ensure you have enough power to capture those crucial moments.

Charging Options

The Nikon Z9 offers two main charging options for its battery:

1. **In-Camera Charging:** This is the most convenient method for charging the battery while the camera is turned off.

 - **Requirements:**
 - Nikon Z9 camera
 - Nikon EN-EL18D battery (included with the camera)
 - Nikon MH-33 battery charger (included with the camera)
 - EH-7P charging AC adapter (included with the camera)
 - **Steps:**

1. Turn off the camera.

2. Insert the EN-EL18D battery into the MH-33 battery charger.

3. Connect the EH-7P charging AC adapter to the MH-33 battery charger.

4. Plug the AC adapter into a power outlet.

5. The camera charge lamp (w) on the camera body will light amber while charging and turn off when charging is complete (around 3 hours and 40 minutes for an exhausted battery).

2. **USB-C Charging:** The Z9 also allows you to charge the battery while it's still inside the camera using a USB-C cable and power source.

 - **Requirements:**
 - Nikon Z9 camera
 - Nikon EN-EL18D battery (inside the camera)
 - USB-C cable (not included with the camera, needs to be USB PD compatible)

- USB-C power source (e.g., USB-C wall charger, power bank)
 - **Important Notes:**
 - Nikon recommends using a USB-C cable that supports USB PD (Power Delivery) for faster charging. The standard USB cable supplied with the camera cannot be used for charging.
 - The charging time will vary depending on the power source. A typical USB-C wall charger might take longer than the in-camera charging method.
 - Some users have reported needing a specific USB-C PD certified charger to ensure successful charging. Consult your camera manual or online resources for more details on compatible power sources.

Here's a quick comparison of the two charging options:

Feature	In-Camera Charging	USB-C Charging
Convenience	Very convenient, no need to remove battery	Can be convenient for on-the-go charging, but requires a compatible USB-C cable and power source
Speed	Faster charging times (around 3 hours 40 minutes for exhausted battery)	Charging time can vary depending on the power source, typically slower than in-camera charging
Best Use	Ideal for charging the battery at home or in a studio environment	Useful for charging on the go when you don't have access to an outlet

Additional Tips:

- It's recommended to keep a spare EN-EL18D battery for extended shooting sessions.
- Avoid using extreme temperatures while charging the battery.
- Use genuine Nikon batteries and chargers for optimal performance and safety.

Power Accessories and Battery Grips

The Nikon Z9 offers a variety of power accessories and battery grips to enhance your shooting experience and extend battery life:

Power Accessories:

- **Nikon EH-6d AC Adapter:** This AC adapter plugs directly into the camera and allows for continuous power while using the camera. It's ideal for studio shooting or situations where you need the camera to be powered on for extended periods.

- **Nikon EP-6a Power Connector:** This connector is required to connect the EH-6d AC adapter to the Z9 camera.

- **External Power Banks:** While not officially endorsed by Nikon, some users have reported success using high-capacity USB-C power banks to charge the Z9 externally while the camera is on. It's important to ensure the power bank supports USB PD (Power Delivery) for faster charging and sufficient wattage to power the camera effectively.

Battery Grips:

- **Third-Party Battery Grips:** Currently, there are no Nikon-branded battery grips available for the Z9. However, some third-party manufacturers offer battery grips that are compatible with the Z9. These grips typically hold one or two additional EN-EL18D batteries, significantly extending your shooting time. Before purchasing a third-party grip, ensure it has good reviews and is compatible with the Z9 to avoid functionality or safety issues.

Choosing the Right Power Accessory:

- **Consider your shooting needs:** If you primarily shoot in controlled environments like studios, an AC adapter might be a good choice. For travel or outdoor photography where portability is important, a spare battery or a compatible USB-C power bank might be more suitable.

- **Battery life requirements:** If you find yourself frequently running out of battery power, a battery grip can be a valuable investment.

- **Compatibility:** Ensure any third-party accessories you choose are compatible with the Nikon Z9.

Additional Tips:

- Invest in a spare EN-EL18D battery to avoid missing shots due to a dead battery.

- Carrying a car charger can be helpful for charging the battery while traveling.

- External battery packs can add weight to your camera setup, so consider the trade-off between portability and extended shooting time.

By understanding the available power accessories and battery grips, you can choose the ones that best suit your shooting style and ensure you have enough power to capture all those important moments with your Nikon Z9.

Energy-Saving Tips

Here are some energy-saving tips to help you maximize battery life on your Nikon Z9:

In-Camera Settings:

- **Enable Energy Saving Mode:** The Z9 offers an energy-saving mode within the menu. This mode might slightly reduce display refresh rates, but it can significantly improve battery life.

- **Auto Power Off:** Set the camera to automatically turn off after a period of inactivity. This prevents the camera from draining battery while not in use.

- **Review Time:** Adjust the image review time to a shorter duration. Constantly reviewing images on the screen consumes battery power.

- **Display Brightness:** Reduce the display brightness, especially when shooting outdoors on a bright day. A lower brightness level is still sufficient for composing your shots and saves battery life.

- **Focus Mode:** If you're not actively tracking moving subjects, switch from continuous autofocus (AF-C) to single autofocus (AF-S). Continuous autofocus uses more power to constantly maintain focus lock.

- **Wireless Connectivity:** Turn off Wi-Fi and Bluetooth when you're not using them to transfer images or connect to your smartphone. These features can drain the battery in the background.

Shooting Habits:

- **Minimize LCD/EVF Use:** Rely on the viewfinder (EVF) for composing your shots whenever possible. The LCD screen consumes more power, especially when tilted or brightened.

- **Turn Off Camera When Not Shooting:** Don't leave the camera on standby mode for extended periods. Get in the habit of turning it off completely when you're not actively capturing images.

- **Review Images on Playback Mode:** Limit using the image review function while shooting. Instead, wait until you're done shooting and review images in playback mode for a more detailed analysis.

- **Avoid Extreme Temperatures:** Extreme hot or cold temperatures can reduce battery life. If possible, store and use your camera in moderate temperatures.

- **Keep Firmware Updated:** Ensure your Z9 firmware is updated to the latest version. Sometimes, firmware updates can include improvements to battery efficiency.

Additional Tips:

- **Carry a Spare Battery:** Investing in a spare EN-EL18D battery is the most effective way to extend your shooting time.

- **External Power Sources:** Consider using a USB-C power bank with PD (Power Delivery) compatibility for on-the-go charging. This allows you to recharge the battery without needing an outlet.

- **Battery Grip:** For extended shooting sessions, a third-party battery grip that holds additional batteries can be a valuable accessory.

By implementing these energy-saving tips and carrying a spare battery, you can ensure your Nikon Z9 is ready to capture those perfect shots throughout your entire shoot. Remember, a little planning and adjustments to your shooting habits can significantly improve your camera's battery life.

CHAPTER EIGHT
LENS COMPATIBILITY AND OPTIONS

Nikon Z Mount Lenses

Nikon Z mount lenses are a series of lenses designed specifically for Nikon's full-frame mirrorless camera system. These lenses offer a wide range of focal lengths, apertures, and features to suit the needs of both professional and amateur photographers.

Here are some of the different categories of Nikon Z mount lenses available:

- **Prime Lenses:** These lenses have a fixed focal length and typically offer a wider aperture and sharper image quality compared to zoom lenses.

- **Zoom Lenses:** These lenses offer a variable focal length, allowing you to frame your shots more flexibly without needing to change lenses.

- **Wide-Angle Lenses:** These lenses have a wide field of view, making them ideal for capturing landscapes, cityscapes, and group photos.

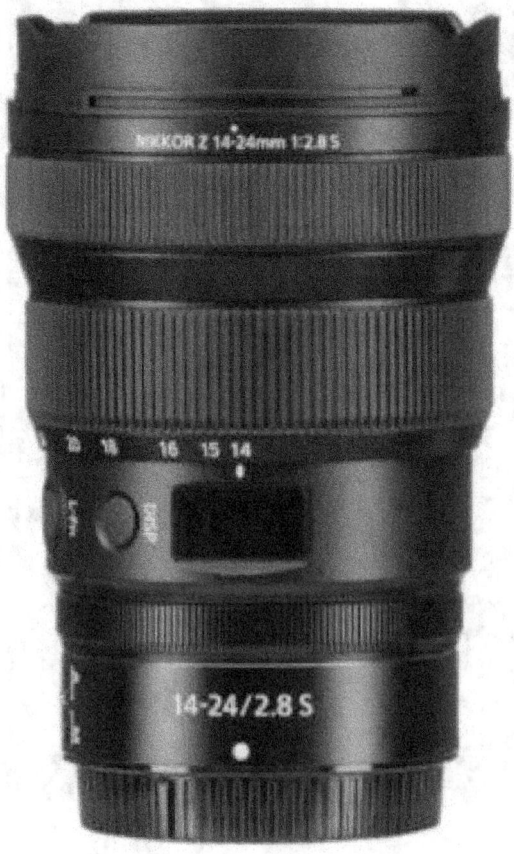

- **Standard Lenses:** These lenses offer a moderate focal length similar to the human eye's field of view, making them versatile for various photography styles.

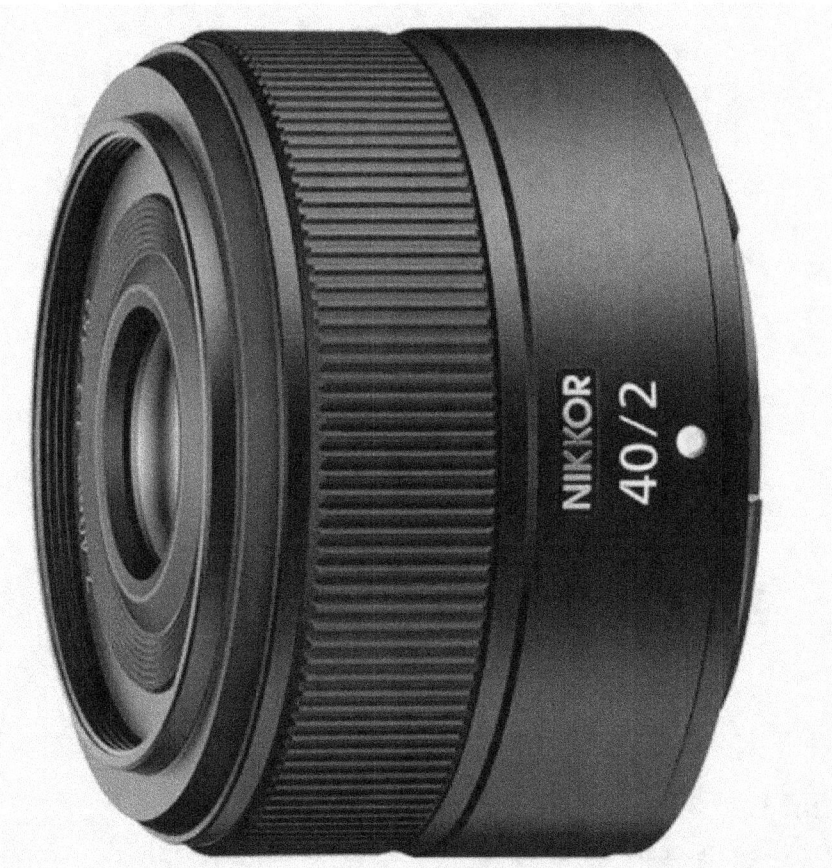

- **Telephoto Lenses:** These lenses have a long focal length, allowing you to capture distant subjects in more detail.

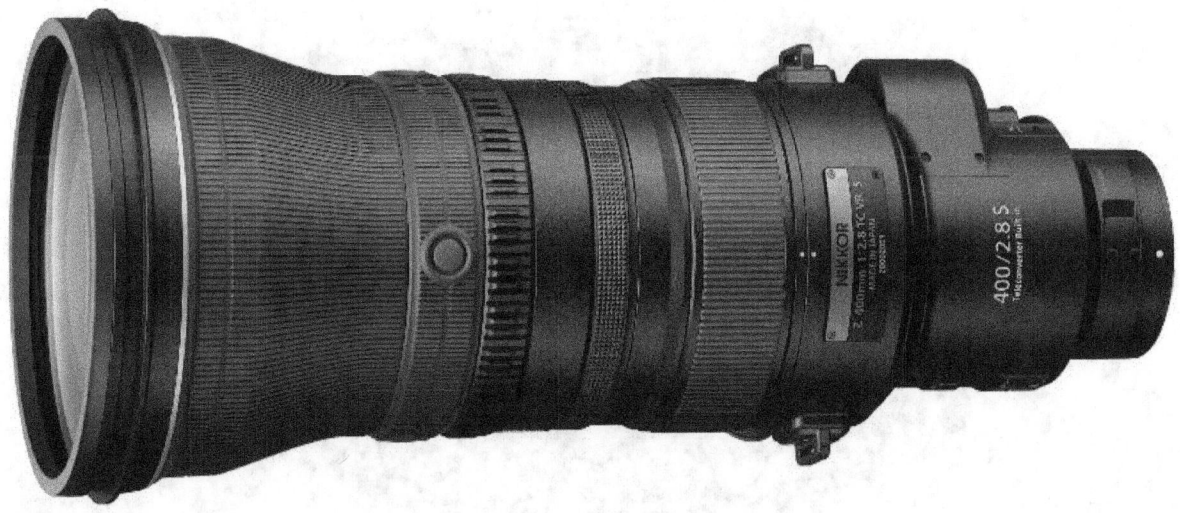

- **Macro Lenses:** These lenses are designed for extreme close-up photography, allowing you to capture intricate details of small subjects.

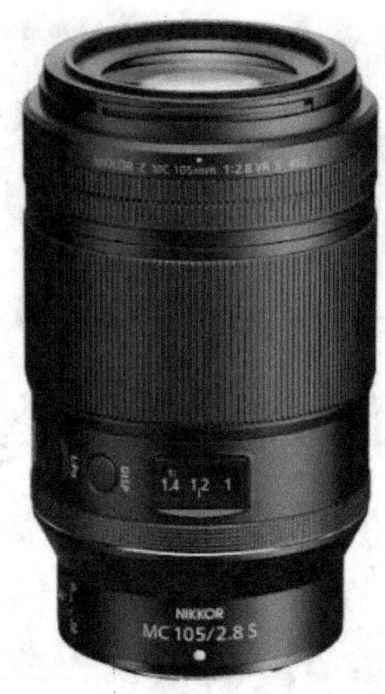

Adapting F Mount Lenses

The Nikon Z mount system is designed for their mirrorless cameras, while F mount lenses are made for Nikon's DSLR cameras. However, Nikon offers an adapter that allows you to seamlessly use your existing F mount lenses on your Nikon Z mirrorless camera. This adapter is called the **Nikon Mount Adapter FTZ II**.

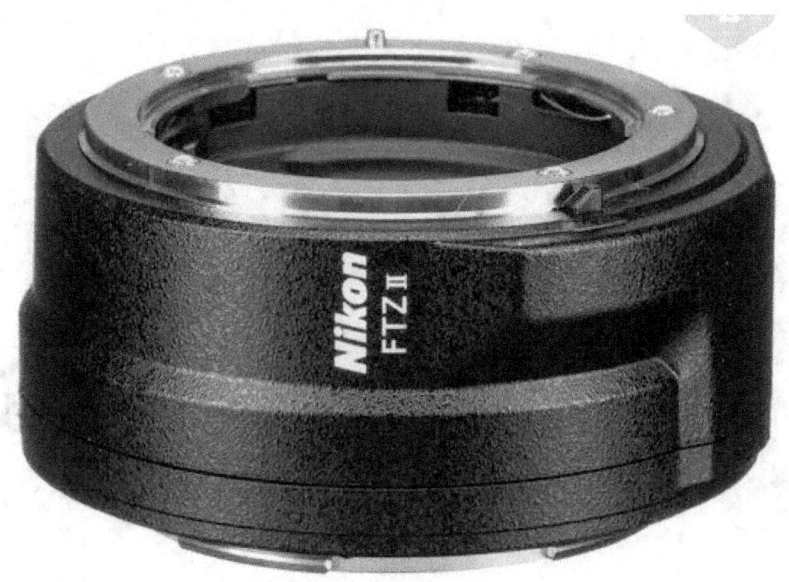

Benefits of Using the Nikon Mount Adapter FTZ II:

- **Preserves Investment:** You can continue using your existing F mount lenses on your new Nikon Z camera, saving you the cost of buying entirely new lenses.

- **Maintains Functionality:** The adapter allows for autofocus and auto-exposure with a wide range of F mount lenses, ensuring a smooth shooting experience.

- **Weather Sealed:** The adapter is built with weather sealing, protecting your camera and lens from dust and moisture, especially useful for outdoor shooting.

- **Wide Compatibility:** The Nikon Mount Adapter FTZ II is compatible with over 360 different F mount lenses, giving you a vast selection to choose from.

Things to Consider:

- **Not all F mount lenses are compatible:** While a vast majority work, there might be a few older F mount lenses that don't function entirely with the adapter. You can check Nikon's compatibility list to ensure your specific lens works with the FTZ II adapter.

- **Potential for slight performance decrease:** In some cases, autofocus performance or image quality might be slightly reduced compared to using a native Z mount lens. However, for most users, the difference is negligible.

Overall, the Nikon Mount Adapter FTZ II is a valuable accessory for Nikon Z camera users who own F mount lenses. It allows you to leverage your existing lens collection and enjoy the benefits of a mirrorless camera system.

Third-Party Lens Support

Nikon Z mount is relatively young compared to other mirrorless mounts like Sony E or Canon RF. While Nikon offers a growing selection of high-quality Nikkor Z lenses, there are also third-party lens manufacturers entering the Z mount market.

Here's a breakdown of third-party lens support for Nikon Z cameras:

Current Situation:

- **Limited Options:** Compared to the extensive selection of third-party lenses available for other mirrorless mounts, Nikon Z mount currently has a more limited selection. However, the options are growing steadily.

- **Focus on Manual Lenses:** Many current third-party Z mount lenses are manual focus lenses, offering a good value for budget-conscious photographers who prioritize image quality over autofocus functionality. Popular brands include Voigtlander, Meike, and 7artisans.

- **Emerging Autofocus Options:** Some third-party manufacturers are starting to offer autofocus lenses for Nikon Z mount. Tamron offers a 24-70mm f/2.8 zoom and a 70-300mm f/4.5-6.3 telephoto zoom, both with autofocus capabilities. Sigma has also announced upcoming Z mount lenses with autofocus.

Benefits of Third-Party Lenses:

- **Cost-effective:** Third-party lenses are often more affordable compared to their Nikon counterparts, allowing you to expand your lens collection without breaking the bank.

- **Unique Options:** Third-party manufacturers might offer focal lengths or specific features not available in the native Nikkor Z lens lineup.

- **Encourages Competition:** More lens choices from different brands can drive innovation and potentially benefit consumers with better features or prices.

Things to Consider:

- **Autofocus Compatibility:** Not all third-party lenses offer autofocus functionality on Nikon Z cameras. Ensure the lens you choose is compatible if autofocus is important for your shooting style.

- **Warranty and Support:** Third-party lenses might have different warranty policies and support channels compared to Nikon lenses.

- **Build Quality and Performance:** While some third-party lenses offer excellent quality, it's wise to research reviews and user experiences before purchasing to ensure the lens meets your expectations.

Third-party lens support for Nikon Z mount is on the rise. While the selection is still evolving, there are already some compelling options available, especially for photographers comfortable with manual focus or looking for budget-friendly alternatives. As the Z mount system matures, we can expect the third-party lens selection to continue expanding and offer more choices for Nikon Z users.

Best Lenses for Different Scenarios

Choosing the right lens depends on the kind of photography you want to do. Here's a breakdown of some of the best Nikon Z mount lenses for different shooting scenarios:

Landscape Photography:

- **Nikon Z 14-24mm f/2.8 S:** This wide-angle zoom lens is ideal for capturing expansive landscapes with stunning sharpness and edge-to-edge clarity, even at wider apertures.

- **Nikon Z 24-70mm f/4 S:** This versatile zoom lens offers a good balance between wide and telephoto capabilities, allowing you to capture landscapes, architecture, and even some closer details. It's also relatively compact and lightweight for travel photography.

- **Nikon Z MC 105mm f/2.8 VR S Macro:** While primarily a macro lens, the MC 105mm f/2.8 VR S can also be a great choice for landscape photography, especially when you want to include foreground elements with beautiful bokeh and sharp detail.

Portrait Photography:

- **Nikon Z 85mm f/1.8 S:** This excellent prime lens offers a classic focal length for portraits with a fast aperture for beautiful background blur and low-light shooting.

- **Nikon Z 50mm f/1.8 S:** Another fantastic prime lens, the 50mm f/1.8 S is a more affordable option that still delivers exceptional image quality and a versatile focal length for various portrait styles.

- **Nikon Z 70-200mm f/2.8 VR S:** This telephoto zoom lens is perfect for portrait photographers who prefer to work with a bit more distance or compress the background for a more flattering look. The fast f/2.8 aperture allows for excellent low-light performance and creamy bokeh.

Sports and Wildlife Photography:

- **Nikon Z 70-200mm f/2.8 VR S:** As mentioned earlier, the 70-200mm f/2.8 VR S is a great choice for photographers who need to capture fast-action subjects or wildlife from a distance. The fast aperture and image stabilization make it ideal for low-light situations and maintaining sharp focus on moving subjects.

- **Nikon Z 100-400mm f/4.5-5.6 VR S:** This telephoto zoom lens offers even more reach for capturing distant wildlife or sporting events. While the aperture isn't quite as fast as the 70-200mm f/2.8, it's still good enough for most lighting conditions, and the zoom range provides incredible versatility.

- **Nikon Z 400mm f/2.8 TC VR S:** This top-of-the-line telephoto prime lens is a professional-grade option for wildlife and sports photographers who demand the absolute best in image quality, speed, and autofocus performance.

Travel Photography:

- **Nikon Z 24-70mm f/4 S:** The compact and versatile 24-70mm f/4 S is a great all-around lens for travel photography, allowing you to capture landscapes, cityscapes, architecture, and even portraits without needing to switch lenses frequently.

- **Nikon Z 24-200mm f/4-6.3 VR:** This all-in-one zoom lens offers a massive zoom range, eliminating the need to carry multiple lenses while traveling. While the aperture varies throughout the zoom range, it's still suitable for most travel photography situations.

Nikon Z DX 16-50mm f/3.5-6.3 VR: This lightweight zoom lens (for APS-C sensor Nikon Z cameras) is incredibly compact and perfect for travel photography where portability is a priority.

CHAPTER NINE
IMAGES QUALITY AND OUTPUT

RAW and JPEG Options

The Nikon Z9 offers flexible options for capturing images in RAW, JPEG, or both RAW and JPEG formats. Here's a breakdown of these options and their pros and cons:

RAW vs JPEG:

- **RAW:**
 - **Pros:** RAW captures all the sensor data from the image, providing maximum flexibility for editing in post-processing software. You can adjust white balance, exposure, shadows, highlights, and achieve more detail recovery compared to JPEG.
 - **Cons:** RAW files are much larger than JPEGs, requiring more storage space on your memory cards. They also need to be processed in editing software before you can share them.

- **JPEG:**
 - **Pros:** JPEGs are smaller file sizes, allowing you to fit more images on a memory card and share them more easily. The camera applies basic in-camera processing for color and sharpness.
 - **Cons:** JPEGs discard some image data during compression, limiting your editing capabilities compared to RAW. Adjustments like white balance and exposure changes might result in reduced image quality.

Nikon Z9 RAW and JPEG Options:

- **Image Quality (Menu):** Navigate to the **Shooting Menu** and select **Image Quality**. Here you can choose:
 - **RAW:** Captures only uncompressed RAW images.
 - **FINE JPEG:** Highest quality JPEG setting with minimal compression.
 - **NORMAL JPEG:** Good balance between image quality and file size.
 - **BASIC JPEG:** Smaller file size with more compression, suitable for web sharing or less critical situations.
- **RAW Size (Optional):** Depending on your camera settings, you might have an option to select the RAW file size. Some cameras offer compressed or uncompressed RAW options, allowing a trade-off between file size and maximum image quality.

Choosing the Right Option:

- **For maximum editing flexibility and professional use, RAW is the preferred choice.**

- **If you need to conserve storage space or prioritize quick sharing, JPEG is a good option.** Especially consider using FINE JPEG for situations where you still want good image quality for editing.

- **The Nikon Z9 also allows you to shoot RAW+JPEG simultaneously.** This is a good compromise if you want the benefits of both formats. You'll get the flexibility of RAW for editing and a ready-to-share JPEG. However, this will consume double the storage space.

Additional Tips:

- **Consider your editing workflow.** If you heavily rely on post-processing software, RAW is more suitable.

- **Think about storage space and sharing needs.** If storage is limited or you need to share images quickly, JPEG might be more practical.

- **Experiment with both RAW and JPEG** to see which format works best for your shooting style and workflow.

By understanding the pros and cons of RAW and JPEG formats, and the options available on the Nikon Z9, you can make informed decisions about how to capture your images.

Image Processing and Editing

The Nikon Z9 produces high-quality images straight out of the camera, but editing can further enhance them and bring out their full potential. Here's a look at the image processing workflow and popular editing software options for your Z9 photos:

In-Camera Editing (Basic Adjustments):

The Z9 offers some basic image editing capabilities in-camera:

- **RAW Processing:** Access the **Playback Menu** and navigate to **RAW processing**. Here you can make adjustments like white balance, Picture Control settings (presets that affect colour and image style), and image cropping. These adjustments are non-destructive to the original RAW file.

- **Image Review:** During image review, you can apply basic edits like D-Lighting (brightens shadows) or retouching minor dust spots. These edits are typically meant for JPEGs and might not be available for RAW files.

External Image Editing Software:

For more comprehensive editing capabilities, you'll want to use external software on your computer. Here are some popular options:

- **Adobe Photoshop Lightroom Classic:** An industry-standard software offering a wide range of tools for RAW processing, exposure adjustments, noise reduction, colour correction, local adjustments (selective edits on specific areas), lens corrections, and creative effects. Lightroom Classic also excels at image organization and management.

- **Adobe Photoshop:** While primarily known for photo manipulation and graphic design, Photoshop offers powerful tools for RAW editing similar to Lightroom Classic. It also boasts advanced features for compositing images, creating HDR photos, and retouching. However, Photoshop has a steeper learning curve compared to Lightroom.

- **Capture One Pro:** A professional-grade software specifically designed for RAW processing. It offers excellent image quality, advanced noise reduction, tethered shooting capabilities (direct camera to computer connection for live view and image transfer), and lens profile corrections for various Nikon lenses.

- **Nikon NX Studio:** Nikon's free software suite for RAW processing, image editing, and file transfer. It provides basic to moderate editing tools, including noise reduction, white balance adjustments, and image sharpening. While not as feature-rich as professional editing software, Nikon NX Studio is a user-friendly option for basic RAW processing and managing your Z9 photos.

Choosing the Right Software:

- **Consider your editing needs and budget.** Professional software like Lightroom Classic or Capture One Pro offers the most extensive features, but comes with a subscription cost. Free options like Nikon NX Studio provide basic editing but might not be suitable for advanced tasks.

- **Evaluate the software's learning curve.** Lightroom Classic and Nikon NX Studio have a more user-friendly interface, while Photoshop offers more power but requires a steeper learning curve.

- **Look for free trials.** Many editing software programs offer free trials, allowing you to test them out before committing.

Additional Tips:

- **Export settings:** Once you've edited your images, you can export them in various formats (JPEG, TIFF, etc.) and adjust the quality and size depending on your needs (sharing online, printing).

- **Non-destructive editing:** Most editing software allows for non-destructive editing, which means the original RAW file remains untouched. This gives you the flexibility to revisit edits later without losing image quality.

- **Online resources:** There are numerous online tutorials, articles, and video courses available to help you learn more about image editing and master the software of your choice.

By effectively utilizing in-camera editing options and leveraging the power of external software, you can elevate your Nikon Z9 images and achieve stunning results. Remember, the best editing software depends on your individual needs and preferences. Explore different options, experiment with editing techniques, and have fun unlocking the full potential of your Z9 photos!

Output Formats and Options

The Nikon Z9 offers a variety of output formats and options for your photos and videos, allowing you to tailor the final files to your specific needs. Here's a breakdown of the key output formats and options available:

Image Output Formats:

- **RAW (.NEF):** This is the camera's raw sensor data containing the most detail and flexibility for editing in post-processing software. However, RAW files are much larger than JPEGs and require conversion before sharing.

- **JPEG (.JPG):** A compressed format offering a good balance between image quality and file size. JPEGs are suitable for sharing online, printing, or situations where you don't need extensive editing. The Z9 offers various JPEG quality settings (FINE, NORMAL, BASIC) affecting file size and image quality.

- **RAW+JPEG:** This option allows you to capture both a RAW file and a JPEG simultaneously. This provides the benefits of RAW for editing and a ready-to-share JPEG. However, it consumes double the storage space.

Image Quality Settings (Shooting Menu):

Within the Shooting Menu, you can access the Image Quality settings to choose your desired output format and quality:

- **Image Quality:** Select RAW, FINE JPEG, NORMAL JPEG, or BASIC JPEG.

- **RAW Size (Optional):** Depending on your camera settings, you might have an option to select the RAW file size (compressed or uncompressed) for a trade-off between file size and image quality.

Video Output Formats:

- **MOV (H.264):** This is the standard video format on the Z9, offering good compatibility with various editing software and playback devices. The Z9 allows you to choose different video resolutions and frame rates within the Movie Menu, impacting file size and video quality.

- **ProRes RAW HQ (with optional external recorder):** This high-quality format offers maximum detail and editing flexibility for professional videographers. However, ProRes RAW files are extremely large and require a compatible external recorder (not included with the Z9) for capturing footage.

Video Recording Settings (Movie Menu):

The Movie Menu provides controls for setting video output formats:

- **Frame Size/Frame Rate:** Choose the desired video resolution (e.g., 8K, 4K, Full HD) and frame rate (frames per second). Higher resolutions and frame rates will result in larger file sizes.

- **Video Recording Options:** Access additional settings like Active D-Lighting (improves shadow detail in videos) and video bit depth (affects colour detail).

Additional Output Options:

- **HDMI Output:** The Z9 can output video to an external monitor or recorder via the HDMI port. Within the Setup Menu, you can adjust the HDMI resolution output format.
- **White Balance (for Video):** Maintain consistent white balance throughout your video recording for a natural look.

By understanding these output formats and options, you can choose the settings that best suit your needs. Consider factors like:

- **Editing requirements:** RAW files offer maximum editing flexibility, while JPEGs are suitable for basic editing or quick sharing.
- **Storage space:** RAW and high-resolution video files are large and require significant storage space.
- **Video editing software:** Ensure your chosen video format is compatible with your editing software.
- **Sharing platform:** Choose an output format suitable for your intended use (online sharing, printing, professional video editing).

Remember, the Nikon Z9 empowers you with a variety of output options. Experiment with different settings to find the perfect balance between image/video quality, file size, and your workflow requirements.

Printing and Publishing

The Nikon Z9 is a powerful camera capable of producing high-resolution images ideal for printing and publishing. Here's a workflow to follow and some key considerations for getting the most out of your Z9 photos when it comes to printing and publishing:

Pre-Printing Workflow:

1. **Transfer Images:** Download your photos from the Z9 to your computer using a card reader or tethered shooting (direct camera to computer connection).

2. **Image Processing (Optional):** For optimal results, consider editing your photos in software like Adobe Photoshop Lightroom Classic or Capture One Pro. Here you can make adjustments to improve exposure, white balance, colour correction, and overall image quality.

3. **Resize (Optional):** Most printing services or publishers will have specific size requirements for images. Resize your photos accordingly using your editing software while maintaining image quality.

4. **File Format:** Ensure your photos are in a format compatible with the printing service or publisher. JPEG is the most widely accepted format, while TIFF files might be preferred for professional printing due to their lossless compression.

Printing Options:

- **Professional Printing Service:** Many online and local professional printing services offer high-quality printing on various papers and finishes (matte, glossy, canvas). They can handle large file sizes and offer advanced printing techniques for exceptional results.

- **Home Printing:** If you have a good quality photo printer, you can print your photos at home. However, keep in mind that home printer quality might not match that of professional services, and paper selection might be limited.

Publishing Options:

- **Online Platforms:** Numerous online platforms like Flickr, 500px, or Instagram allow you to share your photos with a global audience. These platforms typically have size and resolution limitations, so be sure to adjust your photos accordingly.

- **Self-Publishing:** For creating your own photo books or printed portfolios, services like Blurb or Shutterfly offer user-friendly tools to design and publish your work.

- **Stock Photography:** If your photos have commercial value, consider submitting them to stock photo agencies like Getty Images or Shutterstock. These agencies have specific submission guidelines regarding image quality and resolution.

Additional Considerations:

- **Paper Quality:** For professional printing, choose high-quality paper that complements your image and purpose (archival paper for longevity, fine art paper for a specific look).

- **Colour Calibration:** Ensure your monitor is properly calibrated to ensure accurate colour representation between your edits and the final printed output.

- **Resolution and Sharpening:** High-resolution Z9 images provide ample detail for large prints. However, excessive sharpening during editing might result in artifacts in the final print. Consult your printing service or publisher for specific recommendations.

- **Copyright and Licensing:** Be mindful of copyright laws, especially when publishing your work online or submitting to stock agencies.

By following these steps and considering the printing/publishing options available, you can ensure your Nikon Z9 photos are showcased beautifully in print or shared effectively in the digital publishing world.

CHAPTER TEN
USER INTERFACE AND CUSTOMIZATION

Menu System Overview

The Nikon Z9's menu system offers a comprehensive range of settings and customizations for optimizing your camera's performance and tailoring it to your shooting style. Here's a breakdown of the main menus and their functionalities:

Shooting Menu:

- **Exposure Controls:** This section lets you adjust aperture, shutter speed, ISO, exposure compensation, and metering mode. You can choose manual, aperture priority, shutter priority, or program mode.

- **White Balance:** Set the white balance to achieve accurate colour reproduction under different lighting conditions (daylight, incandescent, fluorescent, etc.).

- **Autofocus:** Fine-tune autofocus settings like AF mode (single point, continuous, subject tracking), focus area selection, and focus sensitivity.

- **Image Quality:** Select the desired image resolution (megapixels), file format (JPEG, RAW, or both), and image quality settings (fine, normal, basic).

- **Movie Menu:** Access settings specifically for video recording, including frame size, frame rate, video codec, and white balance settings for video.

- **Shooting Banks:** A convenient feature allowing you to save and quickly switch between frequently used shooting setups with specific combinations of settings.

Playback Menu:

- **Image Review:** Review captured photos and videos. You can zoom in, view image information, and delete unwanted images.

- **Playback Options:** Adjust playback settings like image rotation, slideshow playback, and image information overlay.

- **RAW Processing:** Perform basic in-camera edits on RAW images, such as white balance adjustments, image cropping, and picture control adjustments.

- **Protect Images:** Protect specific images from accidental deletion.

- **Copy Images:** Copy images between memory cards.

Setup Menu:

- **Date and Time:** Set the correct date, time, and time zone information.
- **Display:** Adjust display settings for the electronic viewfinder (EVF) and rear LCD screen, including brightness, color balance, and information display options.
- **Sound:** Control camera sounds like shutter clicks, beeps, and audio recording settings.
- **Connectivity:** Manage Wi-Fi, Bluetooth connections, and file transfer settings.
- **Buttons:** Customize the functions assigned to specific camera buttons for a personalized shooting experience.
- **Formatting:** Format memory cards to erase all data and prepare them for use with the camera.
- **Reset Menu:** Reset the camera to factory settings.

Custom Setting Menu:

This extensive menu provides in-depth customization options for various camera functions. It's further divided into sub-menus for specific areas:

- **Autofocus:** Fine-tune autofocus tracking sensitivity, subject detection, and AF activation settings.
- **Metering:** Adjust metering parameters for different shooting scenarios.
- **Exposure:** Customize exposure bracketing settings and auto exposure lock (AE lock) behaviour.
- **Timers:** Set self-timer delays and interval timer shooting for timelapse photography.
- **AE Lock/Shooting Display:** Configure the auto exposure lock button behaviour and information displayed during shooting.
- **Flash:** Control flash settings like flash mode, flash power, and commander mode for wireless flash control.
- **Custom Controls:** Assign specific functions to programmable buttons and dials for a more efficient workflow.
- **Video:** Access advanced video recording settings like focus peaking and zebra stripes for exposure control during video shooting.

Understanding the Menu System:

- **Navigation:** The Z9's menu system is navigated using the multi-selector joystick, menu button, and playback button. The joystick allows you to move through menus and adjust settings. The menu button displays the main menus, and the playback button switches to the playback menu for image review.
- **Contextual Help:** The Z9 offers a helpful contextual help system. When highlighting a menu option, a brief explanation of the setting appears on the screen.

- **Customization:** While the menus might seem complex at first, the Z9 allows you to personalize the button functions for easier access to frequently used settings.

By familiarizing yourself with the menu structure and exploring the different settings, you can unlock the full potential of your Nikon Z9 and tailor it to your specific shooting needs. Refer to the camera manual for detailed explanations of each menu option and setting.

Customizing Controls and Buttons

The Nikon Z9 offers extensive customization options for its buttons and dials, allowing you to tailor the camera's controls to your shooting style and frequently used functions. Here's how to customize controls and buttons on your Z9:

Accessing the Custom Setting Menu:

1. Press the **Menu Button (MENU)** on the top left of the camera.
2. Navigate to the **Custom Setting Menu (c)** tab using the multi-selector joystick.
3. Press the **multi-selector joystick button (J)** to enter the Custom Setting Menu.

Custom Controls Menu:

Within the Custom Setting Menu, navigate to the **f: Custom Controls** submenu. This section allows you to assign specific functions to various camera buttons and dials. Here's a breakdown of customization options:

- **Function Buttons (Fn):** The Z9 has several programmable function buttons (Fn) conveniently located on the camera body. You can assign various functions to these buttons, such as ISO, white balance, metering mode, autofocus mode, or even custom shooting banks.
- **AE-L/AF-L Button:** This button by default activates the auto-exposure lock (AE lock) function. However, you can customize it to perform other actions like AF lock (AF-L) or assign a completely different function like movie recording start/stop.
- **Multi-selector Button:** The canter button of the multi-selector joystick can also be customized to trigger specific actions, such as magnify the image during playback or activate the depth-of-field preview.
- **Custom Dials (Front and Rear):** The Z9 features two command dials, one on the front and one on the rear of the camera. By default, the front dial controls aperture and the rear dial controls shutter speed in shooting mode. However, you can swap these functions or assign entirely different controls to these dials, such as exposure compensation or ISO adjustment.

Customizing the Process:

1. Navigate to the desired function you want to customize within the **f: Custom Controls** menu.
2. Press the **multi-selector joystick button (J)**.

3. You'll see a list of assignable functions for that particular button or dial.
4. Use the multi-selector joystick to highlight the desired function you want to assign.
5. Press the **multi-selector joystick button (J)** to confirm the selection.

Tips for Effective Customization:

- **Identify Frequently Used Settings:** Consider the functions you use most often while shooting and prioritize assigning them to easily accessible buttons or dials. For example, if you frequently change ISO, assign it to a function button.

- **Maintain Consistency:** Strive for a logical button layout that you can memorize easily. Assign similar functions to buttons with similar locations (e.g., all white balance settings to specific function buttons).

- **Experiment and Adapt:** The beauty of customization lies in personalization. Try different configurations and see what works best for your workflow. You can always revisit the Custom Controls menu and adjust button assignments as needed.

By customizing the controls and buttons on your Nikon Z9, you can significantly enhance your shooting experience and achieve a more efficient workflow. Remember, the goal is to personalize the camera's controls to your preferences, allowing you to focus on capturing stunning images without fumbling through menus.

My Menu and Quick Access Settings

The Nikon Z9's menu system offers a vast range of options, and customizing it to your specific needs can significantly improve your shooting experience. Here's a breakdown of two key features that can streamline your workflow:

My Menu:

- **Function:** My Menu is a customizable menu that allows you to quickly access frequently used settings without navigating through the entire menu system. This is a great way to keep the features you use most often readily available.

- **Customizing My Menu:**
 1. Press the **Menu Button (MENU)** on the top left of the camera.
 2. Navigate to the **d: My Menu** tab using the multi-selector joystick.
 3. Press the **multi-selector joystick button (J)** to enter the My Menu settings.
 4. You'll see a list of existing menu items in My Menu. By default, it might include some Nikon-selected options.
 5. To add or remove items: Press the **Options button (i)**. This will display options to **Add Items** or **Delete Items**.

6. **Adding Items:** Highlight the **Add Items** option and press **J**. You'll see a list of all available menu options from the camera's main menus. Use the joystick to navigate and select the items you want to add to My Menu. Press **J** to confirm the selection. The added items will appear in your My Menu.

7. **Deleting Items:** Highlight the item you want to remove in My Menu and press the **Options button (i)**. Select **Delete** and press **J** to confirm.

Quick Access Settings (i Menu):

- **Function:** The i Menu is a context-sensitive menu that provides quick access to frequently used shooting settings. It appears on the screen when you press the **i button** on the camera body. The specific options displayed in the i Menu will vary depending on whether you're in photo mode or video mode.

- **Customizing the i Menu (Limited Options):** While the i Menu options are primarily based on the current shooting mode (photo or video), you can customize some aspects.

 1. Press the **Menu Button (MENU)** on the top left of the camera.
 2. Navigate to the **c: Custom Setting Menu** tab using the multi-selector joystick.
 3. Press the **multi-selector joystick button (J)** to enter the Custom Setting Menu.
 4. Navigate to the **a: Shooting/Playback** submenu.
 5. Select the **i Button (i menu)** option and press **J**.
 6. Here you can choose to display or hide specific settings in the i Menu, such as metering mode, white balance, or image quality. However, the overall customizability of the i Menu is more limited compared to My Menu.

Effective Use of My Menu and i Menu:

- **My Menu:** Compile settings you use frequently across different shooting modes (photo or video) in My Menu for quick access regardless of the mode you're in. Examples could be ISO, white balance, focus mode, or bracketing settings.

- **i Menu:** This menu is ideal for adjusting settings specific to the current shooting mode. For instance, in photo mode, you might use it to adjust aperture, shutter speed, or exposure compensation. In video mode, it could be for frame rate or video profile settings.

By strategically using My Menu and the i Menu, you can significantly reduce the time spent navigating through the main menu system and focus more on capturing the perfect shot. Remember, customization is key! Tailor these features to fit your shooting style and frequently used functions for a more efficient and enjoyable photographic experience with your Nikon Z9.

Setting Up User Profiles

The Nikon Z9, unfortunately, doesn't currently offer a user profile system in the traditional sense. This means you can't create multiple profiles with entirely different sets of shooting configurations. However, there are functionalities on the Z9 that can achieve a similar outcome to user profiles:

1. My Menu and Quick Access Settings (i Menu):

As explained previously, these features allow you to customize the menus for easier access to frequently used settings.

- **My Menu:** Organize settings you use often across various shooting modes (photo and video) for quick access regardless of the current mode. This can function similarly to a user profile by having specific settings readily available for different shooting styles (portrait, landscape, sports photography).

- **i Menu (Limited Customization):** While the i Menu options are context-sensitive, you can personalize it to display specific settings relevant to your preferred shooting style. For example, a portrait photographer might want to prioritize options for white balance and focus mode, while a sports photographer might Favor settings related to autofocus and shutter speed.

2. Shooting Banks:

- **Function:** Shooting Banks allow you to save and quickly switch between frequently used shooting setups with specific combinations of settings. This acts like a profile for a particular shooting scenario.

- **Creating and Using Shooting Banks:**

 1. Navigate to the **Shooting Menu (camera icon)** using the mode dial.
 2. Scroll down and highlight **Shooting Bank**.
 3. Press the **multi-selector joystick button (J)**. You'll see available banks (usually Bank 1 and Bank 2).
 4. To create a new bank, select an empty bank (indicated by "--").
 5. The camera will display the current shooting settings. You can now modify these settings (aperture, shutter speed, ISO, white balance, autofocus, etc.) to your desired configuration for a specific shooting situation.
 6. Once you've adjusted the settings, press the **MENU button** to exit the menu and save the configuration to the chosen Shooting Bank.
 7. To switch between Shooting Banks, press the **Shooting Bank button (play symbol with a square around it)** on the back of the camera and use the multi-selector joystick to choose the desired bank.

By combining My Menu customization, i Menu adjustments, and Shooting Banks, you can achieve a similar effect to user profiles on the Z9. While you can't have entirely separate profiles with unique names, you can create designated sets of settings readily accessible for different shooting scenarios or preferences.

CHAPTER ELEVEN
MAINTENANCE AND CARE

Cleaning and Maintenance

The Nikon Z9, like any camera, requires proper cleaning and maintenance to ensure optimal performance and longevity. Here are some key practices to follow:

Sensor Cleaning:

- **Importance:** Dust on the camera sensor can cause spots to appear in your images. Regularly cleaning the sensor is crucial for maintaining image quality.

- **Cleaning Method:** Nikon recommends using their cleaning kit specifically designed for mirrorless cameras. This kit typically includes cleaning swabs and sensor cleaning fluid.

- **Frequency:** The frequency of sensor cleaning depends on your shooting environment. If you frequently shoot in dusty or sandy environments, you might need to clean the sensor more often. A good rule of thumb is to inspect the sensor for dust every few months and clean it if necessary.

- **Warning:** Sensor cleaning can be a delicate process. If you are uncomfortable cleaning the sensor yourself, it is best to take your camera to a Nikon authorized service centre for professional cleaning.

Body Cleaning:

- **Cleaning Cloth:** Use a soft, dry microfiber cloth to wipe down the camera body. Avoid using abrasive cloths or chemicals, as these can damage the camera's finish.

- **Cleaning Frequency:** Clean the camera body regularly, especially after shooting in dusty or humid environments.

Lens Care:

- **Front and Rear Elements:** Use a blower brush or compressed air to remove dust particles from the front and rear elements of your lenses. Avoid touching the lens elements with your fingers, as this can leave fingerprints and smudges.

- **Lens Cap:** Always keep the lens cap on when the lens is not in use. This will help protect the lens from dust, scratches, and fingerprints.

- **Storage:** Store your camera and lenses in a cool, dry place when not in use. Avoid storing them in extreme temperatures or direct sunlight.

Additional Tips:

- **Battery Care:** Remove the battery from the camera if you won't be using it for an extended period. This will help to preserve the battery life.

- **Firmware Updates:** Keep your Z9's firmware up to date. Nikon periodically releases firmware updates that can improve camera performance and fix bugs. You can check for updates and download them from the Nikon website.

By following these cleaning and maintenance practices, you can help ensure that your Nikon Z9 continues to deliver exceptional image quality for years to come. If you have any concerns about cleaning your sensor or other maintenance tasks, consult your camera's manual or contact Nikon support for assistance.

Storage and Transportation

Here's how to properly store and transport your Nikon Z9 to ensure it stays safe and functions optimally:

Storage:

- **Cool and Dry Environment:** Store your Z9 in a cool, dry place with moderate temperature and humidity. Avoid extreme temperatures or areas with rapid temperature fluctuations, as this can cause condensation and potentially damage the camera's delicate electronics.

- **Dust-Free Location:** Keep your camera in a dust-free environment. Dust on the sensor can impact image quality, so minimize your Z9's exposure to dusty areas.

- **Separate from Batteries:** If you won't be using your Z9 for a long time, it's best to remove the battery and store it separately. This helps preserve battery life and prevent potential damage from battery leakage.

- **Original Packaging (Optional):** If you have the original packaging, it can be a good option for storing your Z9 as it provides a snug fit and protects the camera from bumps.

Short-Term Transport (Within Your Home/Studio):

- **Camera Strap or Wrist Strap:** When carrying your Z9 for short distances around your home or studio, use a comfortable camera strap or wrist strap to keep it secure and prevent accidental drops.

Long-Term Transport (Travel/Outdoors):

- **Camera Bag:** Invest in a well-padded camera bag specifically designed for mirrorless cameras like the Z9. The bag should have compartments to hold your camera body, lenses, and accessories. Choose a bag that is the appropriate size for your gear and comfortable to carry for extended periods.

- **Padding and Compartments:** Adequate padding within the bag is crucial to absorb bumps and shocks during transport. Compartments help organize your gear and prevent items from bumping against each other.

- **Weather Resistance:** Consider a weather-resistant bag if you anticipate shooting or traveling in wet or dusty conditions.

- **Hard Shell Case (Optional):** For maximum protection, especially during air travel or rough transport, a hard-shell case can be a good option. However, hard shell cases can be bulky and heavy, so weigh the need for extra protection against portability.

Additional Tips:

- **Empty Memory Cards:** Before storing or transporting your Z9, ensure there are no memory cards inserted. This helps prevent accidental data loss or damage to the memory card.

- **Lens Caps:** Always keep lens caps on your lenses when not in use to protect the front element from scratches and dust.

- **Airplane Travel:** Check airline regulations regarding camera equipment for carry-on luggage. Lithium-ion batteries typically need to be carried-on, so keep this in mind when packing your camera bag.

By following these storage and transportation practices, you can ensure your Nikon Z9 remains secure and functions flawlessly whenever you pick it up to capture stunning images.

Troubleshooting Common Issues

Even with a high-end camera like the Nikon Z9, you might encounter some occasional issues. Here's a breakdown of common problems you might face and some troubleshooting steps you can try:

Battery Issues:

- **Camera Won't Turn On:** If your Z9 won't turn on, the battery might be dead or improperly inserted. Ensure the battery is fully charged and correctly inserted according to the camera manual.

- **Fast Battery Drain:** If the battery drains quickly, several factors could be at play. Using features like the high-resolution EVF, Wi-Fi, or Bluetooth can consume more power. Additionally, extreme cold temperatures can also reduce battery life. Try turning off these features when not in use and consider carrying a spare battery for extended shoots.

Focus Issues:

- **Soft or Out-of-Focus Images:** Ensure your focus mode is set correctly for the shooting situation. Experiment with different autofocus modes like single-point AF, continuous AF, or subject tracking AF depending on your subject. Also, verify if autofocus is set to focus on the desired subject within the frame.

Image Quality Issues:

- **Blurry Images:** Camera shake can cause blurry images. Ensure you're using a shutter speed fast enough to freeze motion blur. If necessary, use a tripod or enable image stabilization features. Blurry images can also be caused by focusing on the wrong subject. Double-check your focus point selection.

- **Grainy Images (Noise):** Grainy images with visible noise are often caused by shooting in low-light conditions with a high ISO setting. Try lowering your ISO if possible or using techniques like noise reduction during post-processing.

Error Messages:

- **Memory Card Errors:** If you encounter memory card errors, format the card in the camera or try using a different memory card. Ensure the memory card is compatible with the Z9 and has sufficient storage capacity.

Other Issues:

- **Camera Freezes:** If your camera freezes, try turning it off and on again. If the freezing persists, reset the camera to factory settings (consult your manual for instructions). In rare cases, the camera might require service by a Nikon authorized service canter.

- **Overheating:** In very hot environments, the Z9 might overheat and shut down to protect its internal components. If this occurs, turn off the camera and let it cool down before restarting.

Additional Tips:

- **Consult the Manual:** The Nikon Z9 manual provides detailed troubleshooting information for various error messages and common issues. Refer to the manual for specific solutions.

- **Nikon Support:** If you've tried troubleshooting and the problem persists, contact Nikon support for further assistance. They can offer additional solutions or recommend service if necessary.

- **Firmware Updates:** Keeping your Z9's firmware up to date can sometimes resolve bugs and improve camera performance. Check for and install the latest firmware updates from the Nikon website.

By understanding these common issues and following the troubleshooting steps, you can effectively resolve most problems you might encounter with your Nikon Z9. Remember, if you're unsure about any issue, consulting the camera manual or contacting Nikon support is always a good course of action.

CHAPTER TWELVE
ACCESSORIES AND ADD-ONS

Essential Accessories

Besides the camera body and lens, there are several essential accessories that can significantly enhance your Nikon Z9 experience and improve the quality of your photos. Here are some of them:

- **Memory Cards:** The Nikon Z9 is compatible with CFexpress Type B memory cards. These cards offer significantly faster read and write speeds compared to traditional SD cards, which is crucial for capturing high-resolution photos and videos at high frame rates. Invest in high-performance CFexpress Type B cards with sufficient storage capacity to avoid running out of space during shoots.

- **Extra Batteries:** The Nikon Z9 has good battery life, but it can drain faster when using features like the high-resolution EVF, Wi-Fi, or Bluetooth. Carrying a spare battery ensures you can continue shooting for extended periods without interruption.

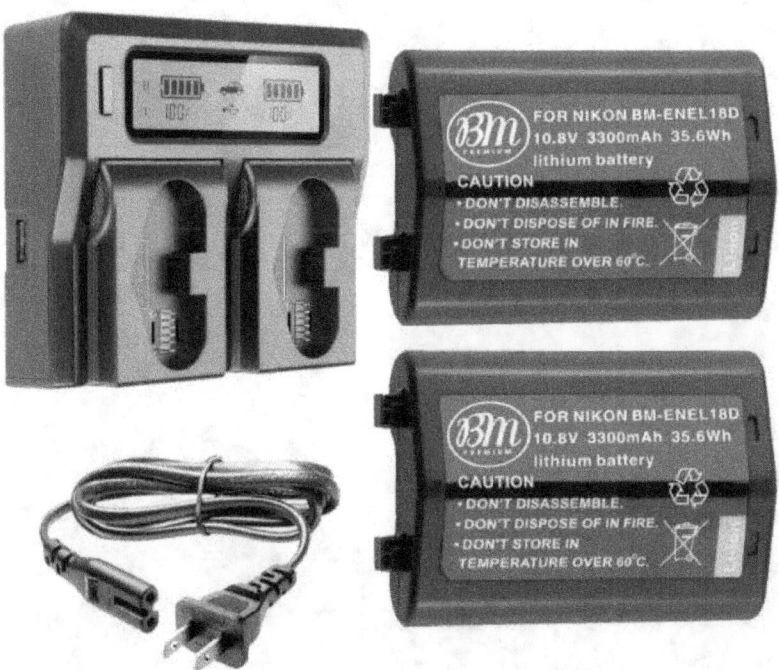

- **Lens Hood:** A lens hood is an essential accessory that helps shield your lens from stray light, which can cause lens flare and reduce image quality. It also offers some physical protection for the front element of your lens.

- **UV Filter:** A UV filter helps protect your lens from dust, scratches, and fingerprints. While not essential for modern lens coatings, it can be beneficial if you frequently shoot in harsh environments or for peace of mind. However, some photographers prefer not to use UV filters as they can slightly reduce image quality.

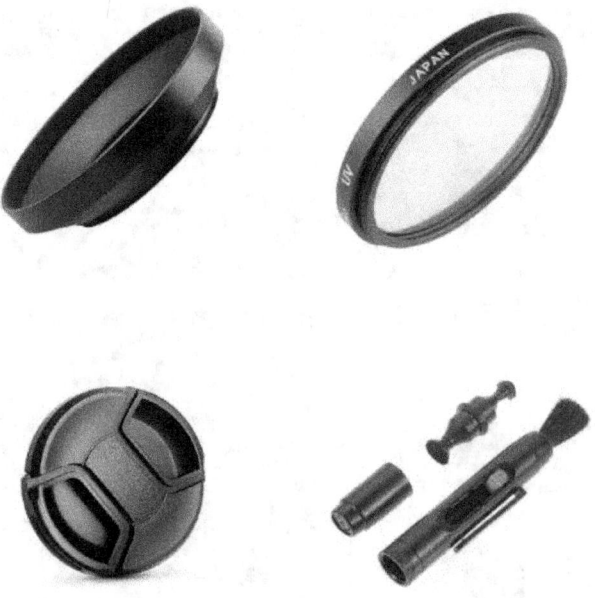

- **Camera Strap:** A comfortable camera strap helps you carry your Z9 securely and conveniently. Especially helpful for situations where you need to have your camera readily accessible but don't want to carry it in a bag.

- **Tripod:** A sturdy tripod is essential for low-light photography, long exposure shots, and situations where you need maximum image stability. The Z9's in-body image stabilization (IBIS) is effective, but a tripod offers even greater stability for sharper images.

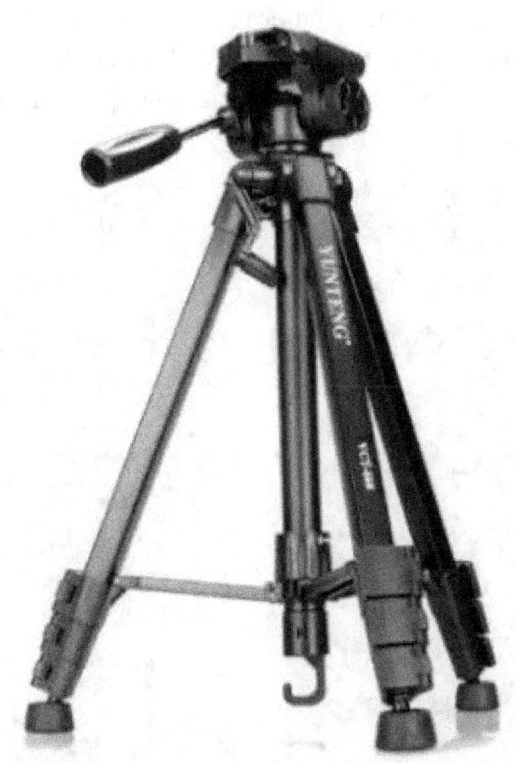

- **External Microphone:** The Z9 has a built-in microphone, but for improved audio quality while recording videos, consider using an external microphone. This can be especially useful for capturing clear audio in noisy environments or for professional video productions.

- **Remote Shutter Release:** A remote shutter release allows you to trigger the shutter of your Z9 wirelessly or with a cable connection. This can be helpful for situations where you need to minimize camera shake, like in long exposure photography, or when you want to capture photos from a distance.

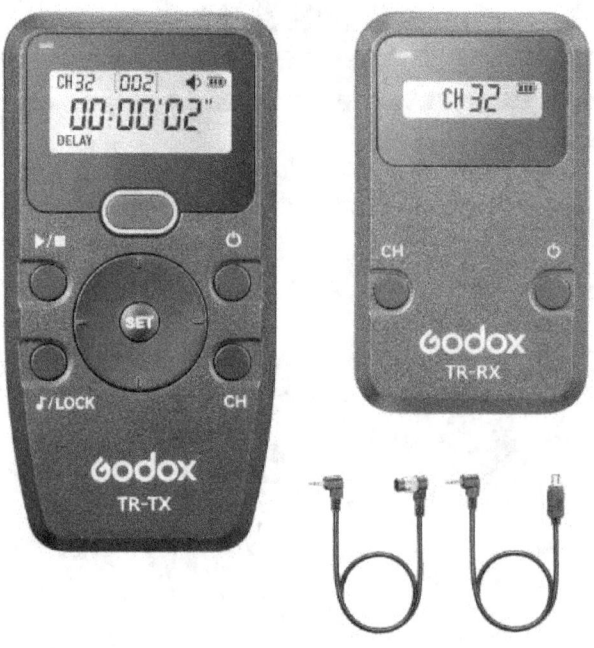

- **Camera Bag:** A camera bag is essential for protecting your Z9 and lenses while transporting them. Choose a bag that is well-padded, weather-sealed, and has enough space for your camera, lenses, and accessories. Consider the type of photography you do and choose a bag that suits your needs.

Lighting and Flash Systems

While the Nikon Z9 boasts impressive low-light capabilities, external lighting systems can significantly enhance your creative control and image quality. Here's a breakdown of lighting and flash options for the Nikon Z9:

Nikon Speedlights:

- **Compatibility:** Nikon offers a range of Speedlights (flash units) compatible with the Z9 through Nikon's Creative Lighting System (CLS). These flashes communicate wirelessly with the camera, allowing for flexible flash positioning and off-camera setups. Popular choices include the SB-5000 (top-of-the-line), SB-700 (versatile), SB-500 (compact), and SB-300 (entry-level).

- **Features:** Nikon Speedlights offer various features like bounce flash, zoom flash heads, high-speed sync (HSS) for using flash with fast shutter speeds, and commander mode for wireless control of multiple flashes.
- **Benefits:** Speedlights provide a portable and powerful lighting solution. They are ideal for situations where you need to add fill light, control shadows, or create dramatic lighting effects.

Third-Party Flashes:

- **Compatibility:** Several third-party manufacturers offer flash units compatible with the Nikon Z9, often at more affordable prices compared to Nikon Speedlights. Look for flashes with features like TTL (Through-The-Lens) metering for automatic flash exposure and wireless triggering capabilities. Brands like Godox, Yongnuo, and Flashpoint offer compatible options.
- **Considerations:** While often functional, third-party flashes might not offer the same level of integration or features as Nikon Speedlights. Ensure compatibility with the Z9's CLS system and desired features before purchasing.

Continuous Lighting:

- **LED Panels and Softboxes:** For consistent and soft lighting, consider LED panels and softboxes. LED panels offer adjustable colour temperature and brightness, making them ideal for portrait photography, product photography, or video production. Softboxes diffuse the light, creating a softer and more flattering look compared to direct flash.
- **Studio Strobes:** For professional studio setups, studio strobes offer powerful and precise lighting control. These strobes require separate power packs and can be used with a variety of light modifiers like softboxes, beauty dishes, and snoots.

Choosing a Lighting System:

The ideal lighting system depends on your specific needs and budget. Here are some factors to consider:

- **Portability:** If you need a portable lighting solution for on-location shoots, speedlights or LED panels might be a better choice.
- **Power:** For situations requiring powerful light output, studio strobes are the way to go.
- **Features:** Consider the features you need, such as adjustable colour temperature, wireless triggering, and compatibility with light modifiers.
- **Budget:** Lighting systems can range from affordable speedlights to high-end studio setups. Set a realistic budget and choose a system that fits your needs.

Additional Tips:

- **Light Modifiers:** Explore light modifiers like softboxes, beauty dishes, and snoots to shape and control the light's quality.

- **Flash Techniques:** Master flash techniques like bounce flash, fill flash, and rear-curtain sync to achieve creative lighting effects.

- **Experimentation:** The best way to learn lighting is through experimentation. Practice with different lighting setups and see how they affect your images.

By incorporating external lighting, you can take your photography with the Nikon Z9 to the next level. Explore the various options, experiment with different setups, and unlock your creative potential.

Tripods and Stabilizers

Tripods and stabilizers are essential tools for any photographer who wants to capture sharp, high-quality images. They are especially important for the Nikon Z9, which excels at low-light photography and videography, where camera shake can be a significant issue.

Tripods:

- **Stability:** A sturdy tripod provides a stable platform for your camera, ensuring sharp images even at slow shutter speeds. This is crucial for low-light photography, long exposure shots (like for capturing light trails or waterfalls), and astrophotography.

- **Image Quality:** By minimizing camera shake, a tripod allows you to use slower shutter speeds and lower ISOs, resulting in cleaner images with less noise.

- **Versatility:** Tripods come in various sizes and materials, catering to different needs and budgets. Travel tripods are compact and lightweight, ideal for portability, while heavier duty tripods offer maximum stability for professional use.

- **Video Recording:** Tripods are essential for stable video recording, especially when using the Z9's high-resolution video capabilities.

Image Stabilization:

There are two main types of image stabilization to consider:

- **In-body image stabilization (IBIS):** The Nikon Z9 features a built-in 5-axis image stabilization (IBIS) system that helps to compensate for camera shake. However, for critical shots or when using very slow shutter speeds, a tripod can provide even greater stability.

- **Lens stabilization (VR):** Many Nikon Z mount lenses also have built-in Vibration Reduction (VR) image stabilization. VR and IBIS can work together to provide even more effective shake reduction.

Choosing a Tripod:

Here are some factors to consider when choosing a tripod for your Nikon Z9:

- **Height:** Choose a tripod that extends tall enough to allow you to comfortably frame your shots while standing.

- **Weight Capacity:** Ensure the tripod can support the weight of your Z9, lenses, and any additional accessories you might be using.

- **Material:** Tripods are typically made of aluminium or carbon fibre. Aluminium tripods are more affordable but heavier, while carbon fibre tripods are lighter but more expensive.

- **Head type:** Tripod heads come in various configurations, such as ball heads, pan/tilt heads, and geared heads. Ball heads offer quick and easy framing adjustments, while pan/tilt heads provide more precise control for video recording.

Alternatives: Stabilizers:

- **Gimbals:** Gimbals are motorized stabilizers that use sensors and motors to counteract camera shake. They are particularly beneficial for smooth video recording, especially when shooting handheld or on the move. Gimbals can also be used for creative photo techniques like panning timelapse shots.

- **Handheld Gimbals:** These are compact and lightweight gimbals designed for use with mirrorless cameras like the Z9. They are ideal for vlogging, run-and-gun shooting, and capturing smooth video footage while traveling.

- **Larger Gimbals:** These are more robust gimbals that can handle heavier camera setups. They are often used for professional video productions and offer more precise control and features.

Choosing a Stabilizer:

When choosing a stabilizer for your Nikon Z9, consider the following:

- **Weight capacity:** Ensure the stabilizer can support the weight of your Z9, lenses, and any additional accessories you might be using.

- **Payload size:** Make sure the stabilizer is compatible with the physical size of your camera and lens setup.

- **Features:** Some stabilizers offer additional features like zoom controls, focus controls, and long battery life.

- **Ease of use:** Consider how easy it is to operate the stabilizer and how quickly you can balance your camera on it.

By combining the Z9's in-body image stabilization with a tripod or stabilizer, you can achieve maximum image and video quality, even in challenging shooting conditions.

Bags and Cases

There are a variety of bags and cases available to protect your Nikon Z9 and lenses. The best option for you will depend on your needs and how you plan to transport your camera. Here are a few different types to consider:

- **Camera backpacks:** These are a great option for photographers who need to carry a lot of gear. They typically have padded compartments for your camera body, lenses, and accessories, as well as a laptop compartment and a tripod holder.

- **Camera slings:** Slings are a more compact option than backpacks and are a good choice for photographers who want to carry their camera and a few lenses. They are worn over one shoulder and can be quickly swung around to your front for easy access to your camera.

- **Camera inserts:** Inserts are padded bags that can be placed inside of a larger bag, such as a backpack or tote. This is a good option if you want to protect your camera gear but don't need to carry a dedicated camera bag.

- **Hard shell cases:** Hard shell cases offer the most protection for your camera gear. They are a good option if you plan to be traveling with your camera or if you need to store it for long periods of time.

- **Camera pouches:** Pouches are small, soft cases that can be used to protect your camera body or a single lens. They are a good option for photographers who only need to carry their camera and one lens.

When choosing a bag or case for your Nikon Z9, consider the following factors:

- **Size and weight:** Make sure the bag or case is large enough to fit all of your gear comfortably. You don't want a bag that is too heavy or bulky to carry.
- **Padding:** The bag or case should have enough padding to protect your camera gear from bumps and scratches.
- **Compartments:** The bag or case should have enough compartments to organize your gear.
- **Weather resistance:** If you plan to be shooting in bad weather, you may want to choose a bag or case that is weather-resistant.

Carrying comfort: The bag or case should be comfortable to carry. Consider the weight of the bag and the type of straps it has.

CHAPTER THIRTEEN
BEST PRACTICES AND TIPS

Maximizing Image Quality

Here are some tips to help you maximize image quality with your Nikon Z9:

Camera Settings:

- **RAW vs. JPEG:** Shoot in RAW format whenever possible. RAW captures more image data, providing greater flexibility for editing and post-processing compared to compressed JPEGs.

- **Exposure:** Ensure proper exposure for optimal detail and dynamic range. Underexposed images will be dark and noisy, while overexposed images will lose highlights and appear washed out. Use the camera's histogram to monitor exposure levels.

- **White Balance:** Set the white balance accurately to achieve natural-looking colours under different lighting conditions. Choose from presets like Auto White Balance (AWB) for various lighting scenarios, or use Kelvin White Balance for more precise colour temperature control.

- **Aperture:** Aperture controls depth of field. Use a wider aperture (lower f-number) for shallow depth of field to isolate your subject with a blurred background. Conversely, use a narrower aperture (higher f-number) for deeper depth of field to keep both foreground and background sharp.

- **Shutter Speed:** A faster shutter speed is crucial to freeze action and minimize camera shake. However, slower shutter speeds can be used for creative effects like motion blur or light trails. Utilize the camera's image stabilization (IS) to counter camera shake at slower shutter speeds.

- **ISO:** ISO controls light sensitivity. Use the lowest possible ISO for the cleanest images with minimal noise. In low-light situations, raising ISO will brighten the image but introduce noise. Experiment with different ISO settings and find a balance between noise and acceptable light levels.

Lens Choice:

- **High-Quality Lenses:** Invest in high-quality Nikon Z mount lenses that are known for their sharpness and optical performance. These lenses will contribute significantly to image quality.

- **Prime vs. Zoom Lenses:** Prime lenses generally offer superior sharpness and wider apertures compared to zoom lenses. Consider using prime lenses for critical shots where maximum image quality is a priority.

Shooting Techniques:

- **Focus and Composition:** Ensure your subject is in sharp focus and that your composition is balanced and pleasing to the eye. Use autofocus modes and focus points effectively to achieve accurate focus.

- **Camera Stabilization:** Utilize the Z9's in-body image stabilization (IBIS) to minimize camera shake and ensure sharp images, especially at slower shutter speeds or when shooting handheld. You can activate IS in the camera menu.

- **Tripod Use:** For maximum image quality, especially in low light or for long exposures, use a sturdy tripod to keep the camera perfectly still. This minimizes camera shake and allows you to use slower shutter speeds for more creative control.

Post-Processing:

- **RAW Editing:** Take advantage of RAW image editing software like Adobe Lightroom or Capture One. RAW editing allows you to adjust exposure, white balance, noise reduction, and other parameters with more control and flexibility compared to in-camera JPEG processing.

- **Noise Reduction:** RAW editing software offers noise reduction tools to minimize noise introduced at higher ISO settings. Explore these tools to find a balance between noise reduction and image detail preservation.

- **Sharpening:** Slight sharpening in post-processing can enhance image detail and clarity. However, avoid over-sharpening, which can create unwanted artifacts.

Additional Tips:

- **Clean your sensor regularly:** Dust on the camera sensor can cause spots to appear in your images. Regularly clean the sensor using appropriate cleaning tools to maintain optimal image quality.

- **Calibrate your lens:** Over time, autofocus accuracy might slightly shift. Consider having your lens professionally calibrated to ensure consistent sharp focus.

By following these tips and experimenting with different settings and techniques, you can unlock the full potential of the Nikon Z9 and capture stunning high-quality images. Remember, practice and experimentation are key to mastering your camera and achieving the image quality you desire.

Tips for Efficient Shooting

Here are some helpful tips to maximize your efficiency and workflow while shooting with the Nikon Z9:

Preparation and Organization:

- **Pre-plan your shoot:** Think about the shots you want to capture beforehand. Consider factors like lighting, composition, and camera settings you might need for different scenarios. This planning will save time and allow you to focus on capturing the moment when you're on location.

- **Organize your gear:** Pack your camera bag strategically, ensuring you have the necessary lenses, batteries, memory cards, and any other accessories you might need readily accessible.

- **Custom settings:** Customize the Z9's buttons and dials to fit your shooting style. This allows for quick access to frequently used functions and settings. Explore the camera's menu and personalize controls for a more efficient workflow.

- **Use memory card profiles:** Utilize memory card profiles to store and recall specific camera settings. This can be helpful when switching between different shooting scenarios, like landscapes versus portraits.

Shooting Techniques:

- **Master autofocus:** Familiarize yourself with the Z9's autofocus modes and focus points. Learn how to use them effectively to achieve sharp focus on your subjects, especially for fast-paced action or low-light situations.
- **Burst shooting:** Utilize the Z9's impressive burst shooting capabilities to capture fleeting moments or fast-moving action. However, be mindful of filling up your memory cards quickly with burst sequences.
- **Back button focus:** Consider using the back button focus technique. This allows you to separate the focus activation from the shutter release, enabling more precise focus control and recompositing.

Review and Playback:

- **Image review:** Quickly review your captured images on the Z9's high-resolution LCD screen to check focus, exposure, and composition. This allows you to make adjustments if needed before moving on to the next shot.
- **Histogram:** Utilize the camera's histogram to ensure proper exposure. The histogram displays the tonal distribution of your image, helping you avoid under or overexposed shots.
- **Image tagging:** Use the Z9's image tagging feature to categorize your photos on the go. This can be helpful for organizing and finding specific images later during post-processing.

Additional Tips:

- **Learn keyboard shortcuts:** If using the Z9 with Nikon's software like Nikon Transfer Utility or Capture NX-D, familiarize yourself with keyboard shortcuts for faster image transfer, browsing, and basic editing tasks.
- **Battery management:** Carry a spare battery, especially for extended shooting sessions. The Z9's battery life is good, but it can drain faster with heavy use of features like the EVF or Wi-Fi.
- **Format memory cards regularly:** Formatting memory cards periodically helps maintain optimal performance and prevents potential errors during shooting.

By incorporating these tips into your shooting routine, you can streamline your workflow, capture more keepers, and get the most out of your Nikon Z9 experience. Remember, practice and experimentation will help you develop efficient shooting habits that suit your specific needs and shooting style

Advanced Techniques

The Nikon Z9 boasts a range of features that cater to professional photographers who want to push the creative boundaries. Here's a glimpse into some advanced techniques you can explore with your Z9:

Focus Stacking:

- **Macro Photography:** For exceptional detail in macro photography, utilize focus stacking. Capture a series of images where the focus point is progressively shifted throughout the subject. Software then combines these images to create a final photo with exceptional sharpness throughout. The Z9's focus-shift shooting mode can automate this process.

Focus Tracking:

- **Advanced Subject Tracking:** The Z9's subject tracking autofocus excels at following moving subjects. It can recognize and track people, animals (including birds), and even vehicles. This allows you to maintain sharp focus on your subject even during fast-paced action or erratic movements.

Creative Exposure Techniques:

- **HDR (High Dynamic Range) Photography:** Capture scenes with a wider dynamic range by merging multiple exposures. This technique is particularly useful for landscapes with a mix of bright highlights and deep shadows. The Z9's HDR mode can automate this process.

- **Long Exposure Photography:** Experiment with long exposures to capture creative effects. Use a tripod and neutral density (ND) filters to extend shutter speeds and blur elements like water, clouds, or moving traffic, creating a sense of movement or dreamlike atmosphere.

Flash Techniques:

- **High-Speed Sync (HSS):** The Z9's high-speed sync (HSS) allows you to use flash even with fast shutter speeds. This is beneficial for situations where you want to freeze action while still using flash to fill in shadows or control the background.

Video Techniques:

- **Log Gamma Recording:** Utilize the Z9's log gamma recording profiles to capture video with a flat colour profile. This offers greater flexibility for colour grading in post-production, allowing you to achieve a specific look and style for your videos.

- **Timelapse and Timecode:** The Z9 offers built-in timelapse recording for capturing scenes that unfold over time in a compressed format. You can also utilize timecode for precise synchronization during multi-camera video productions.

External Triggering:

- **Off-Camera Flash:** For more creative control over lighting, explore using off-camera flashes with the Z9. You can trigger these flashes wirelessly or with a cable connection for studio setups or creative lighting arrangements.

Software Integration:

- **Tethered Shooting:** Connect the Z9 to your computer via a USB cable for tethered shooting. This allows you to view images on a larger screen in real-time, ideal for studio shoots or situations where precise framing and focus are crucial.

- **Remote Control Apps:** Utilize Nikon's mobile apps like Nikon SnapBridge to remotely control the Z9 from your smartphone or tablet. This can be helpful for capturing photos from awkward angles or triggering the shutter discreetly.

Remember, mastering these advanced techniques takes practice and experimentation. Explore the Z9's features, consult online tutorials, and seek inspiration from professional photographers who employ these techniques. With dedication and creativity, you can unlock the full potential of the Nikon Z9 and capture stunning and unique images.

Learning from Professionals

Here are some excellent ways to learn from professional photographers and elevate your skills with the Nikon Z9:

Workshops and Online Courses:

- **Professional Photography Workshops:** Consider enrolling in photography workshops specifically geared towards the Nikon Z9 or mirrorless cameras. These workshops, often led by professional photographers, provide hands-on experience and personalized feedback in a structured learning environment. You can learn advanced techniques, camera settings, and workflow optimization specific to the Z9. Look for workshops offered by reputable photography schools, professional photographers, or camera stores.

- **Online Photography Courses:** Explore online photography courses focused on advanced techniques or specific genres of photography like landscape, portrait, or wildlife. Many platforms like Skillshare, Udemy, or CreativeLive offer courses tailored to the Nikon Z9 or mirrorless cameras. These courses can be a flexible and convenient way to learn new skills and techniques at your own pace.

Following Professional Photographers:

- **Social media:** Follow professional photographers you admire on social media platforms like Instagram, YouTube, or Twitter. Many photographers share their work, behind-the-scenes glimpses, and insights into their creative process. Pay attention to the types of photos they capture, the techniques they use, and the camera settings they mention.

- **Websites and Blogs:** Visit the websites and blogs of professional photographers known for their work with the Z9 or similar mirrorless cameras. These platforms often feature detailed articles, tutorials, and gear reviews specifically related to the Z9.

Industry Publications and Magazines:

- **Photography Magazines:** Subscribe to photography magazines like Digital Photography Review (DP Review), Popular Photography, or Nikon Pro (Nikon's official magazine). These publications often feature articles written by professional photographers, discussing advanced techniques, camera reviews, and industry trends. Look for articles specifically focused on the Z9 or mirrorless cameras.

- **Online Photography Resources:** Explore websites and online resources dedicated to advanced photography techniques and specific camera models. Websites like Fstoppers or PetaPixel often publish tutorials and articles geared towards professional photographers.

Engaging with Online Communities:

- **Photography Forums:** Actively participate in online photography forums like DP Review Forums or Reddit's r/Nikon subreddit. Here, you can connect with other Z9 users, professional photographers, and enthusiasts. Ask questions, share your work, and get feedback from the community.

Masterclasses and Online Lectures:

- **Online Masterclasses:** Look for online masterclasses offered by renowned photographers or educators. Platforms like Masterclass can provide in-depth insights and learning opportunities from industry leaders. These masterclasses might cover advanced techniques, composition principles, or creative workflows that you can apply to your photography with the Z9.

By actively seeking out these resources and engaging with professionals, you'll gain valuable knowledge, discover new creative approaches, and refine your skills with the Nikon Z9. Remember, continuous learning and inspiration are key factors in growing as a photographer.

CHAPTER FOURTEEN
FREQUENTLY ASKED QUESTIONS (FAQ)

Common Technical Questions

Here are some common technical questions you might encounter regarding the Nikon Z9:

Focusing:

- **What autofocus modes does the Z9 have?** The Z9 offers a variety of autofocus modes, including single-point AF, continuous AF, subject tracking AF (for people, animals, and vehicles), and face detection.

- **How does eye autofocus work on the Z9?** The Z9's eye autofocus can detect and track human or animal eyes, ensuring sharp focus on your subject's eyes.

- **Is the Z9's autofocus good in low light?** Yes, the Z9's autofocus performs well in low light thanks to its advanced sensor and processing power.

Shooting Modes:

- **What are the different shooting modes on the Z9?** The Z9 offers various shooting modes like Program (P), Aperture Priority (A), Shutter Priority (S), Manual (M), Bulb mode, and a variety of scene modes for specific shooting situations.

- **What is the best shooting mode for beginners?** Program mode (P) is a good starting point for beginners as it automatically sets the aperture and shutter speed, allowing you to focus on composition and framing.

- **What is the difference between continuous shooting and burst mode?** These terms are often used interchangeably. Burst mode refers to capturing a rapid sequence of images at high frame rates.

Video Features:

- **What video resolutions and frame rates does the Z9 support?** The Z9 offers impressive video capabilities, including 8K 60p with internal RAW recording, 4K 120p, and Full HD up to 240p for slow-motion effects.

- **Does the Z9 have external microphone and headphone jacks?** Yes, the Z9 has a built-in microphone and a 3.5mm jack for connecting external microphones and headphones.

- **Can I use autofocus while recording video on the Z9?** Yes, the Z9 offers continuous autofocus during video recording.

Connectivity:

- **How do I connect the Z9 to my computer?** You can connect the Z9 to your computer via a USB-C cable to transfer photos and videos.

- **Does the Z9 have Wi-Fi and Bluetooth?** Yes, the Z9 has built-in Wi-Fi and Bluetooth for wireless image transfer, remote camera control, and sharing to social media.

Other Common Questions:

- **What lenses are compatible with the Z9?** The Z9 is compatible with Nikon Z mount lenses.

- **What is the battery life of the Z9?** The Z9's battery life can vary depending on usage, but it is generally considered good for a professional camera.

- **Does the Z9 have an internal flash?** No, the Z9 does not have a built-in flash. You can use an external Nikon Speedlight flash if needed.

By familiarizing yourself with these common questions and their answers, you'll be better equipped to navigate the technical aspects of the Nikon Z9 and unlock its full potential.

Usage and Performance Questions

Here are some common usage and performance questions you might encounter regarding the Nikon Z9:

Handling and Ergonomics:

- **How comfortable is the Z9 to hold?** The Z9 is a larger camera with a full-size grip, designed for comfortable use during long shooting sessions. However, some users might find it bulky or heavy compared to smaller mirrorless cameras.

- **How are the controls on the Z9 positioned?** The Z9 features a comprehensive set of buttons and dials that are customizable for personalized shooting experiences. Learning the button layout might take some time initially.

- **Is the Z9 weather-sealed?** Yes, the Z9 is extensively weather-sealed to protect it from dust, moisture, and occasional splashes. This makes it suitable for professional use in challenging outdoor environments.

Image Quality:

- **How does the Z9 perform in low light?** The Z9 offers good low-light performance with its high-resolution sensor and EXPEED 7 processor. However, some competitor cameras might perform slightly better at extremely low ISOs.

- **How is the image quality at high ISOs?** Image quality remains good up to ISO 6400, with moderate noise levels manageable in post-processing. At higher ISOs, noise becomes more prominent, but details are still recoverable with good noise reduction software.

- **How does the dynamic range of the Z9 compare to other cameras?** The Z9 boasts a wide dynamic range, allowing you to capture a wider range of tones from highlights to shadows, offering more flexibility during editing.

Performance:

- **How fast is the autofocus system of the Z9?** The Z9's autofocus system is considered one of the best among mirrorless cameras, offering fast and accurate subject tracking, even for fast-moving subjects or challenging lighting conditions.

- **What is the burst shooting speed of the Z9?** The Z9 boasts an impressive 20 frames per second continuous shooting speed with full autofocus and autoexposure, making it ideal for capturing fast action or fleeting moments.

- **How is the battery life of the Z9?**
 The battery life of the Z9 is generally considered good for a professional camera, but it can vary depending on usage factors like using the EVF, Wi-Fi, or video recording. Carrying a spare battery is recommended for extended shoots.

Video Features:

- **How does the Z9's video quality compare to dedicated cinema cameras?** While the Z9 offers impressive video capabilities, including 8K RAW recording, dedicated cinema cameras might still offer advantages in terms of sensor size, color science, and professional codecs for high-end filmmaking.

- **Is the Z9 suitable for professional videography?** Absolutely! The Z9's video features, autofocus performance, and internal RAW recording capabilities make it a powerful tool for professional videographers who need a versatile camera for various projects.

- **How is the image stabilization of the Z9 for video recording?** The Z9 offers in-body image stabilization (IBIS) that helps to reduce camera shake for smoother video footage. However, for professional video productions, external gimbals or stabilizers might be used for even more control and smooth motion.

By understanding these usage and performance-related questions, you'll be able to make informed decisions about whether the Z9 is the right camera for your specific shooting needs and workflow.

Troubleshooting Queries

Here are some common troubleshooting queries you might encounter with the Nikon Z9:

Basic Functionality:

- **The camera won't turn on:**
 - Ensure the battery is properly inserted and charged.
 - If using an AC adapter, make sure it's securely connected.
 - Remove and reinsert the battery to perform a soft reset.

- **The camera is unresponsive:**
 - Wait for ongoing processes like recording to finish.
 - If frozen, remove the battery for a forced restart (data currently being processed might be lost).

- **The shutter won't release:**
 - Check if a memory card is inserted and has available space.
 - In mode S (shutter priority), ensure the chosen shutter speed is compatible with the selected aperture.
 - The camera might be set to lock the shutter release when no memory card is present (check menu settings).

Image Quality:

- **Images are blurry:**
 - Verify autofocus is enabled and functioning properly.
 - Ensure the lens is correctly mounted and focused.
 - Consider using a faster shutter speed or image stabilization (if available) to minimize camera shake, especially in low light.

- **Images are too dark or light:**
 - Adjust exposure compensation settings to brighten or darken the image.
 - In some modes, the camera might meter incorrectly; switch to manual mode for more control over exposure.

- **Images have noticeable noise:**
 - Reduce ISO settings for cleaner images, but lower light might necessitate higher ISOs.
 - Use noise reduction software during post-processing to minimize noise at higher ISOs.

Error Messages:

- **"Error: Lens not attached"** Double-check lens attachment and ensure it's clicked into place.
- **"Error: Memory card full"** Transfer or delete images to free up space on the memory card.
- **"Error: Low battery"** Replace the battery with a fully charged one.
- Consult the Z9 manual or Nikon website for specific troubleshooting steps related to various error messages encountered.

Autofocus Issues:

- **Autofocus is slow or inaccurate:**
 - Ensure the chosen focus mode is appropriate for the subject.
 - Check if autofocus points are positioned correctly on the desired subject.
 - In low light, autofocus might struggle; consider using AF-assist illuminator (if available) or manual focus.

Video Recording:

- **Video recording stops unexpectedly:**
 - Ensure the memory card has enough space for video recording, especially for high-resolution formats like 8K.
 - Check if the camera has reached its maximum recording time limit (consult the manual).
- **Video footage is shaky:**
 - Utilize the camera's in-body image stabilization (IBIS) if available.
 - Consider using a tripod or external gimbal for even smoother video recording.

If you've tried these troubleshooting steps and the problem persists, it's recommended to consult the Nikon Z9 manual for more detailed solutions or contact Nikon support for further assistance.

Community Support and Forums

The Nikon Z9 is a powerful camera, but navigating its features and troubleshooting any issues can benefit from the collective knowledge of other users. Here are some excellent resources for finding community support and forums specifically for the Nikon Z9:

Official Nikon Resources:

- **Nikon Online Community:** While not exclusive to the Z9, Nikon's online community offers a forum section for Z series cameras. Here, you can post questions, share experiences, and connect with other Z9 users.

Independent Forums:

- **Nikonians:** This popular forum boasts a dedicated section for the Z9/Z8 discussion. Here, experienced Nikon users discuss everything from camera settings and techniques to troubleshooting and sharing photos captured with the Z9.

- **Fred Miranda - Nikon Forum:** While the forum structure isn't Z9 specific, there's a thriving Nikon forum on Fred Miranda. You can search for threads related to the Z9 or post your questions, and there's a good chance other Nikon users familiar with the Z9 will be able to help.

Social Media Groups:

- **Facebook Groups:** Search for Facebook groups dedicated to the Nikon Z series or specifically the Z9. These groups can be a great way to connect with other users, share photos, and ask questions in a more casual setting.

- **Reddit:** The r/Nikon subreddit is a community of Nikon enthusiasts. While not exclusive to the Z9, you can search for threads or discussions related to the camera and potentially find helpful information or connect with users who can offer advice.

Additional Tips:

- **Search Existing Threads:** Before posting a new question, take some time to search the forums or communities for similar issues or discussions. Chances are, someone else might have encountered the same problem and found a solution.

- **Be Specific:** When asking questions, be as detailed as possible about the issue you're facing. Include information about your camera settings, the situation you were shooting in, and any error messages you encountered. The more specific you are, the easier it will be for others to assist you.

- **Share your Expertise:** As you gain experience with the Z9, don't hesitate to share your knowledge and help others in the community. This fosters a collaborative environment where everyone can learn and grow.

Remember, the online photography community is a valuable resource for learning, troubleshooting, and connecting with other passionate photographers. By actively participating in forums and social media groups, you can expand your knowledge of the Nikon Z9 and get the most out of your photography experience.

CHAPTER FIFTEEN
CONCLUSION AND FUTURE OUTLOOK

Summary of Key Features

The Nikon Z9 is a high-end mirrorless camera designed for professional photographers and videographers. Here's a summary of its key features:

Image Quality:

- 45.7-megapixel stacked CMOS sensor for high-resolution images and good low-light performance.
- Excellent detail and wide dynamic range for flexibility in post-processing.

Speed and Performance:

- Blazing-fast continuous shooting at 20 frames per second with autofocus and autoexposure.
- Incredibly fast electronic shutter with speeds up to 1/32000 of a second, freezing even the fastest action.
- EXPEED 7 image processor for fast performance and advanced features.

Autofocus:

- Nikon's best mirrorless autofocus system yet, with subject recognition for people, animals (including birds), and vehicles.

Video Capabilities:

- Shoots stunning video in formats including 8K 60p with internal RAW recording.

Ergonomics:

- Built for comfort with a full-size body and a built-in vertical grip.
- Extensive weather sealing for protection in challenging environments.
- Customizable controls for personalized shooting experience.

Other Features:

- High-resolution OLED electronic viewfinder with blackout-free viewing.
- Tilting touchscreen LCD for comfortable composing and image review.
- Extensive connectivity options for professional workflows.

Overall, the Nikon Z9 is a powerful and versatile camera that can handle just about any shooting situation. If you're a professional photographer or videographer who needs the best possible performance, the Z9 is a great option.

Here are some things to consider:

- Price: The Z9 is a professional-level camera and priced accordingly.
- Size and weight: It's a larger and heavier camera than some other mirrorless options.
- Flash sync speed: A bit slower than some competitors.

If you're a casual photographer or videographer, or you're on a tight budget, there may be other mirrorless cameras that are a better fit for you.

Future Trends and Upgrades

The future of the Nikon Z9 and mirrorless cameras in general is brimming with exciting possibilities. Here's a glimpse into some potential trends and upgrades we might see:

Sensor Technology:

- **Higher megapixel counts:** Sensors with even higher megapixel counts (possibly exceeding 60MP) could be on the horizon, allowing for even greater image detail and flexibility for cropping or large prints.
- **Improved low-light performance:** Continued advancements in sensor technology will likely bring even better low-light performance, pushing the boundaries of clean image capture in dark environments.
- **Stacked sensor enhancements:** Stacked CMOS sensors like the one in the Z9 might see further refinements, potentially leading to even faster readout speeds and improved low-light capabilities.

Autofocus and Processing Power:

- **Advanced subject recognition and tracking:** Autofocus systems could become even more sophisticated, with more precise subject recognition and tracking capabilities, especially for challenging subjects or fast-paced action.
- **AI-powered image processing:** Artificial intelligence (AI) might play a bigger role in image processing, potentially offering features like automatic scene optimization, real-time noise reduction adjustments, or even AI-powered object selection for focus and exposure.
- **Faster processors:** Faster and more powerful processors will likely become standard, enabling even faster continuous shooting speeds, improved autofocus performance, and smoother 8K or even higher resolution video recording.

Video Features:

- **8K+ recording:** Cameras might go beyond 8K, offering even higher resolution video recording for professional filmmakers and content creators.
- **Advanced codecs:** New and more efficient video codecs could emerge, allowing for higher quality video capture with smaller file sizes.

- **Enhanced video autofocus:** Video autofocus could become even more reliable and performant, ensuring sharp and accurate focus during video recording.

Ergonomics and Design:

- **Articulating electronic viewfinders:** EVFs might gain the ability to tilt or even fully articulate, similar to the tilting LCD screens, offering more flexibility for composing shots from various angles.

- **Voice controls:** Voice commands could become a more integrated way to control camera settings, especially for videographers or photographers who need to keep their eyes focused on the action.

- **Modular designs:** Cameras with modular components might become more prevalent, allowing photographers to customize their camera bodies with different grips, viewfinders, or other accessories for specific shooting needs.

Connectivity:

- **Faster and more reliable wireless connectivity:** Faster Wi-Fi and 5G or even future iterations might enable seamless image transfer, remote camera control, and faster live streaming capabilities.

- **Advanced cloud integration:** Cloud-based storage and editing solutions could become even more tightly integrated with cameras, allowing for seamless photo and video backup, editing, and sharing from anywhere.

It's important to remember that these are just potential future trends, and the actual development roadmap for the Nikon Z9 or its successors might differ. However, they offer a glimpse into the exciting possibilities that lie ahead for mirrorless cameras and the world of photography and videography.

Continuing Education and Resources

As you explore the world of photography and the Nikon Z9 in particular, here are some resources to keep you up-to-date and expand your knowledge:

Nikon Resources:

- **Nikon Official Website:** This is the official starting point for all things Nikon, including product information, manuals, downloads, and support. The Z9 product page will have the latest specs, firmware updates, and potentially tutorial videos.

- **Nikon Online School:** Nikon offers a variety of online courses, some free and some paid, on various photography topics. These can be a great way to learn more about specific features of the Z9 or general photography techniques.

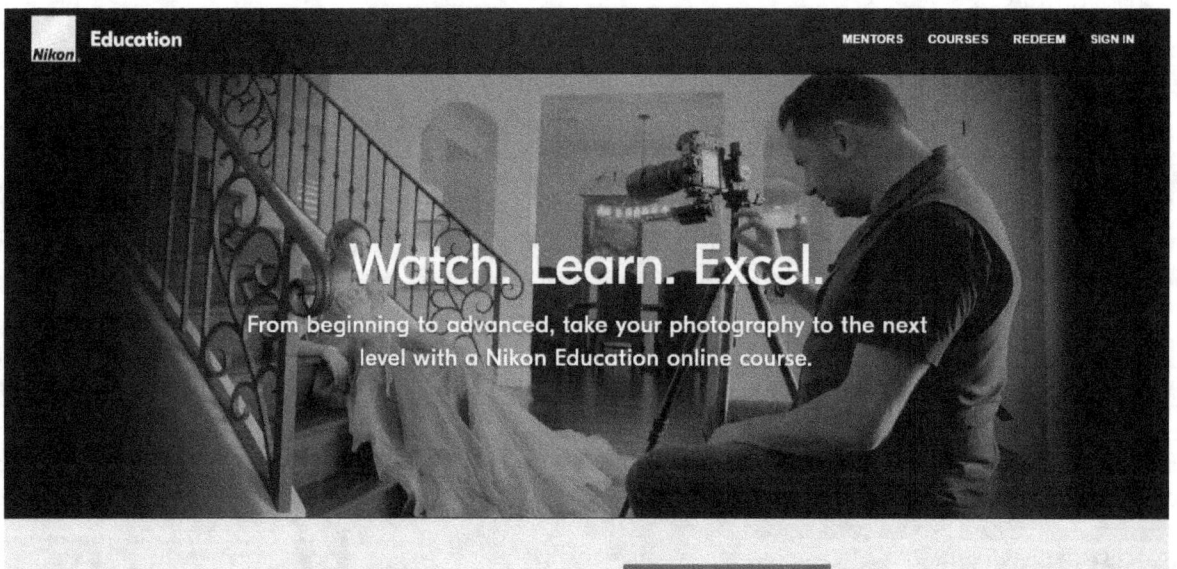

- **Nikon YouTube Channel:** The Nikon YouTube channel has tutorial videos, camera reviews, and inspirational content from professional photographers.

Third-Party Resources:

- **Online Photography Magazines and Websites:** Websites like Digital Photography Review (DP Review), The Verge, and PetaPixel consistently publish reviews, news, and tutorials on the latest cameras and photography techniques. There's a good chance they'll have in-depth reviews and comparisons of the Z9.

- **Photography Blogs and YouTube Channels:** Many professional photographers run their own blogs and YouTube channels, sharing their experiences, workflows, and creative insights. Look for photographers who specialize in genres you're interested in and use mirrorless cameras.
- **Photography Forums:** Online forums like DP Review Forums and Reddit's r/photography subreddit are great places to connect with other photographers, ask questions, and learn from their experiences. You can find threads specifically about the Z9 where users share tips, tricks, and troubleshooting solutions.

Books and eBooks:

There are countless books and eBooks available on digital photography and specific camera models. Look for recent publications that cover mirrorless cameras or the Nikon Z9 specifically. These can provide in-depth information and explanations on various camera functions and shooting techniques.

Workshops and Online Courses:

Consider enrolling in photography workshops or online courses offered by professional photographers or photography schools. These can provide a more structured learning environment where you can gain hands-on experience and personalized feedback.

Remember, the best way to learn is by doing! Experiment with your Nikon Z9, explore different shooting modes and settings, and don't be afraid to push the creative boundaries. The more you practice and explore, the more comfortable and confident you'll become with your camera.

THANK YOU FOR READING

www.ingramcontent.com/pod-product-compliance
Lightning Source LLC
Chambersburg PA
CBHW082235220526
45479CB00005B/1246